Color

A PHOTOGRAPHER'S GUIDE TO DIRECTING THE EYE, CREATING VISUAL DEPTH, AND CONVEYING EMOTION

Jerod Foster

T3-BHM-983

Peachpit

COLOR:
A Photographer's Guide to Directing the Eye, Creating Visual Depth, and Conveying Emotion

Jerod Foster

Peachpit Press
www.peachpit.com

To report errors, please send a note to errata@peachpit.com
Peachpit Press is a division of Pearson Education

Copyright © 2014 Jerod Foster

Senior Editor: Susan Rimerman
Senior Production Editor: Lisa Brazieal
Developmental/Copy Editor: Peggy Nauts
Proofreader: Bethany Stough
Indexer: Emily Glossbrenner
Interior Design and Composition: Kim Scott/Bumpy Design
Cover Design: Charlene Will
Cover Image: Jerod Foster

Notice of Rights

All rights reserved. No part of this book may be reproduced or transmitted in any form by any means, electronic, mechanical, photocopying, recording, or otherwise, without the prior written permission of the publisher. For information on getting permission for reprints and excerpts, contact permissions@peachpit.com.

Notice of Liability

The information in this book is distributed on an "As Is" basis, without warranty. While every precaution has been taken in the preparation of the book, neither the author nor Peachpit shall have any liability to any person or entity with respect to any loss or damage caused or alleged to be caused directly or indirectly by the instructions contained in this book or by the computer software and hardware products described in it.

Trademarks

Many of the designations used by manufacturers and sellers to distinguish their products are claimed as trademarks. Where those designations appear in this book, and Peachpit was aware of a trademark claim, the designations appear as requested by the owner of the trademark. All other product names and services identified throughout this book are used in editorial fashion only and for the benefit of such companies with no intention of infringement of the trademark. No such use, or the use of any trade name, is intended to convey endorsement or other affiliation with this book.

ISBN-13: 978-0-321-93528-1
ISBN-10: 0-321-93528-4

9 8 7 6 5 4 3 2 1

Printed and bound in the United States of America

To my wife and hero, Amanda Waters Foster.

I love you and all the color you bring to my life!

ACKNOWLEDGMENTS

A great number of people come together to produce a book like this, and for each of them, I'm truly thankful!

Specifically, I would like to thank Ted Waitt for commissioning this project. Our conversations over breakfast at Photoshop World brought it to life. Thanks to Susan Rimerman for once again guiding the writing and construction of the content in the direction needed. Thanks also to copy editor Peggy Nauts and proofreader Bethany Stough, who continually make my jumble of words not only readable but much more eloquent than this Texan can express.

Many thanks to the design team of Charlene Charles Will and Kim Scott, who, in following their normal protocol, have created a great-looking book. Thanks to Lisa Brazieal for making all these images look their best alongside the words.

Many thanks also go to others at Peachpit for their work in marketing my books for the past couple of years, including Scott Cowlin, Sara Jane Todd, and publisher Nancy Aldrich-Ruenzel. To the people at Peachpit I have worked with and met over the years, thank you for your friendship, most of all.

I'm very fortunate to not only be a photographer but to also teach photography at Texas Tech University. Thank you especially to the faculty of the College of Media and Communication, and specifically to Dean Jerry Hudson, Ph.D., Dean David Perlmutter, Ph.D., and Todd Chambers, Ph.D., for your continued support in my pursuit of my professional and academic interests.

I most certainly could not have put this project together without the support of those closest to me. I can't thank enough my lovely wife, Amanda, and my ever-curious daughter, Eva, for their patience and comical relief during this process. Thanks also to my parents, Jay and Marsha, for their devotion to my work throughout my life.

To all those I have missed, please know that your support over the years is inspiring and I'm grateful for it. Thank you.

Contents

Introduction

Growing up, I was in love with magazines. I suppose it was the combination of high-quality writing and imagery, the glossy pages, and the booklike heft of the publications. Like many photographers-to-be, I was drawn to the storytelling qualities of *National Geographic*, but the yellow-bordered publication wasn't the first to catch my eye. I'm not afraid to admit that the magazine that attracted me as a youngster was the one and only *Popular Mechanics*. I fondly remember visiting my grandparents' ranch in central Texas, running out to the car shed, and pulling multiple back issues from a dusty shelf—issues that may have sat there for a couple of years before I got to them. I would spend hours looking at the diagrams and the images, occasionally reading a feature on a vehicle manufacturing facility or a how-to piece on building the perfect shop desk. For an eight-year-old who was into airplanes, classic cars, and inventions, it was the perfect magazine. I was (am still) a bit nerdy, to be honest.

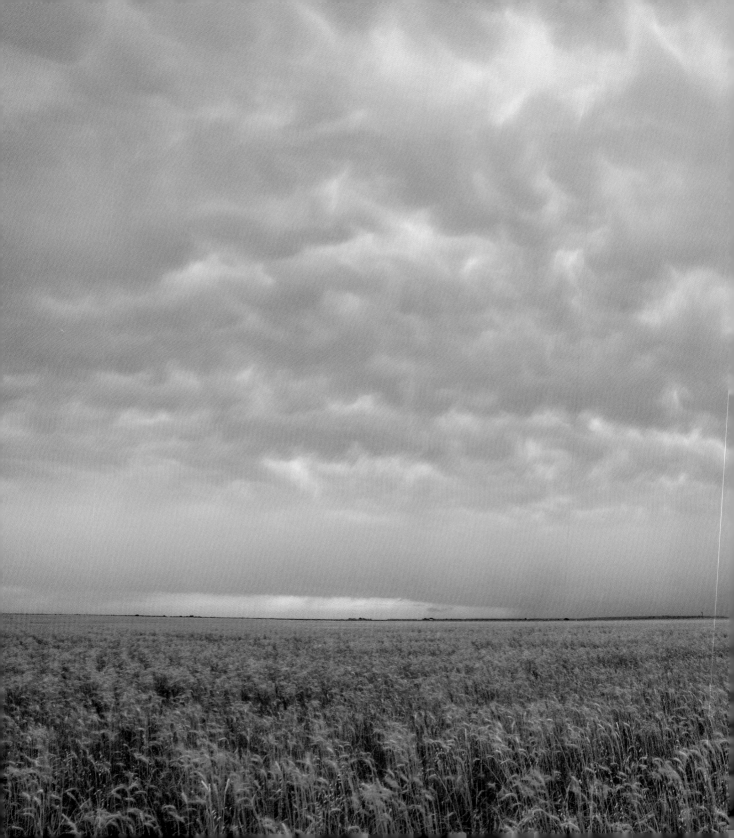

However, I also remember the magazine having very colorful and exciting covers. To this day, when I'm asked about my attraction to magazine photography, I have to say that I was influenced by the eye-grabbing color of *Popular Mechanics* covers. Over the years, my appreciation for color in photographs, cinema, and design has only grown, and it's no wonder why.

As the following text highlights, color is a big deal. It always has been, and it always will be. I was fortunate early on in my photography career to have the chance to build some close relationships with photographers known for their ability to capture outstanding light and the resulting color. Photographers like Wyman Meinzer and Earl Nottingham, to name a couple, were very influential in how I actually looked at light and the colors it created, how colors played out compositionally in a frame, and especially how they emotionally affected viewers. Their work, along with others, showed me just how powerful color might be in my own work.

This book, *Color*, originated in the classroom. Even though I recognized the power of color in photography and sought it in my work, I never felt like I was giving it its due in the introductory photography courses I teach at Texas Tech University. We discussed what color means, but I largely relied on the

One thing I picked up early on from my influences and mentors was to pay attention to unique color, such as this electric-blue thunderstorm moving over a West Texas wheat field.

ISO 50, 1 sec., f/11, 17mm lens

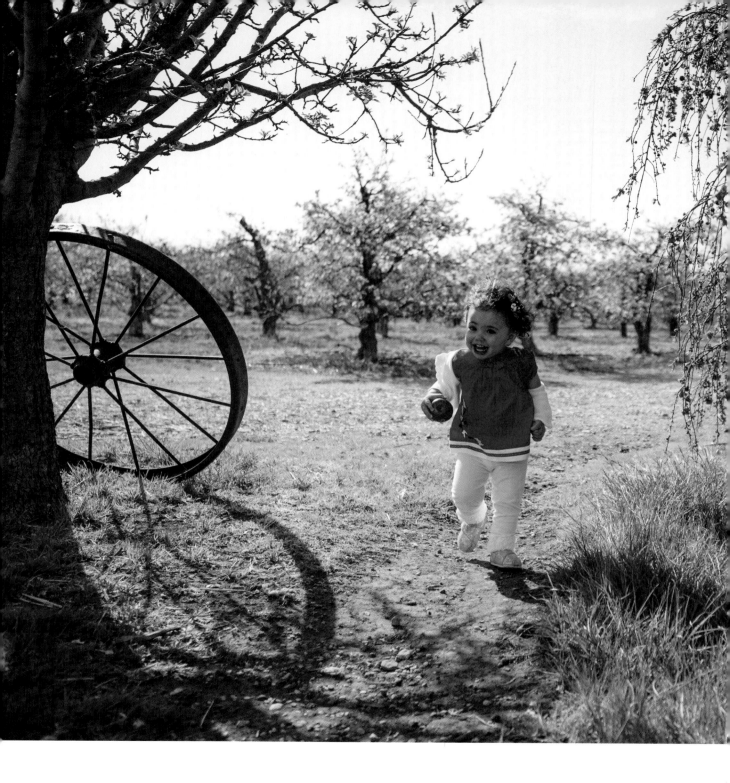

students' studying of other photographers' work and our discussions on great light to inform them about seeing color. I eventually decided that color had to become a more important piece of the photography pie we were creating in those early courses. And so, it did. Taking cues from visual and color theory, as well as from personal experiences and conversations with other photographers and editors, I began to lecture on color in depth, from both mechanical and interpretive perspectives. In creating these lectures, I started to fully realize just how essential of a component color was to my own photography and how I used it in conjunction with other techniques and facets of image making. I wanted my students to see color around them and learn how to take advantage of it, using it to create interesting, storytelling images.

The following chapters have the same intention: to push you to think about, see, and photograph great color. The book addresses color as a universal part of all photography, from landscapes to portraits and everything in between. This is not a theory book (although color theory is addressed early on), but rather a resource for photographers as they become intentional image-makers with an ever-expanding and informing knowledge toolbox. Color is discussed from four primary perspectives: the value of color to our work as photographers, the mechanics of color,

Red to convey energy, white to represent innocence, and green to indicate nature and growth—colors bundled into this fitting photograph of my two-year-old daughter, Eva.

ISO 100, 1/2500 sec., f/2.8, 34mm lens

the universal and cultural interpretive nature of color, and positioning yourself as a photographer to capture great color. The book points out why looking at color abstractly helps in creating great composition and visual depth, as well as how certain colors can pull on emotional strings, adding another component of story to content-filled frames.

Color also identifies situations that are practically great for capturing good color, as well as some techniques to intentionally introduce color. It closes with a set of photography "best practices" the learning shooter can immediately implement on the camera and computer to have as much control as possible over color from the beginning. I draw upon my experience as an editorial, travel, and environmental portrait photographer (and the images reflect that), but the issues discussed apply to all areas of photography.

It probably goes without saying that a book about color runs the risk of stating a few things that seem extremely prescriptive. Aside from the science behind color, the plain and simple of it is: *Color is subjective*. As photographers, we have to make many decisions about the images we make (sometimes before we even go on location), and color is but one of those most human of decisions. This is also the beauty of color in photography—it affects people. Certain colors compel some folks more than others. Although large amounts of bright, dominant colors annoy a good many people, they are attractive to just as many others. To be completely objective about color is to take the human element out of the issue, and last I checked, photographers, and those who view our work, are human. Upon reading Chapters 5 and 6, which are built around interpreting color, it is OK if you disagree with my thoughts, or even more important, if you can identify more meaning than I do in those colors discussed. The chapters provide a more universal approach to deriving meaning from color, but they are appropriately inexhaustive. It is impossible to be otherwise.

It is also imperative to state that this is not a book about printing or manipulating color in post-processing software. It is about seeing and interpreting the color that we photograph and use to tell stories and convey feeling. Although this book dives into an area of photography that is much larger than just shooting, it focuses more on the actual photographic activity than the post-production side of things. I'm of the belief that in order to make the most of color in post, you must make the most of color beforehand. And though I

don't want to sound like some old curmudgeon about post-processing color, I emphasize seeing it photographically. However, I also believe that many of the principles this book touches on can be integrated into a post-processing workflow that entails some or even heavy color manipulation.

Ultimately, the book is a statement of how powerful color can be for your own photography. It is about being aware of it in nature and capturing what you experience for others to see as well. Finally, it is about becoming deeply familiar with how color works and employing it to tell great visual stories.

ISO 400, 1/100 sec., f/2.8, 105mm lens

The World of Color

Color Is Powerful

It's easy to take color for granted. Color is a constant part of our lives. We know the stop sign is red, the grass is green, and that water is blue. Color is so present in our daily walk that most of us barely recognize its power as a visual cue. It's there, though, and it is powerful. Whether subtle or dominating, color is one of the core elements of our visual language, and photographers who pay attention to existing color and how they use it in their images harness that power.

This chapter highlights just how important color is to understanding and communicating about the world around us. When we stop to think about color, we begin to see it in a new light—color is more exciting than we ever realized.

ISO 100, 1/40 sec., f/4, 55mm lens

THINKING ABOUT COLOR

"There is nothing else to be desired but the presentation of these children of light to the astonished eye in the full splendour of their colors."

—Louis Daguerre

How is it that one of the most beloved natural phenomena occurs at the end of the day? On any given evening when the sun goes down, millions if not billions of people get to see it happen. They are privy to the uniquely colorful transformation of the sky, from pale blue to a cascading variety of warm and cool hues, the latter following the former down to the horizon as time passes. If the conditions are just right, clouds make for exciting slashes of reds against dark blues, while oranges and yellows stay molten at the bottom of the display. Thunderstorms can introduce greens into the mix, and every so often, the sky can be as black as coal before the sun has fully set. It is an amazing occurrence that happens every day many places around the world. It could be a time to relax on the patio, near a lake, or simply reflect from a room with a view.

Scientifically, the color's existence is no mystery. Photographers who have shot their fair share of sunsets can predict with a degree of accuracy if it will be a timid one or an explosion of color. But there's just something sunsets do for the soul. The colors in them amaze us, excite us, or put us at ease. It's no wonder that they are also one of the most, if not *the* most, popular and gratifying subjects to photograph.

I get excited about color. I can remember the first time, back in my student days, that I shot on a roll of Fujichrome Velvia (**FIGURE 1.1**), an intensely vivid type of film stock that is very sensitive to reds and greens and has a barely five-stop latitude (that's dynamic range, for you digital folks). I was blown away. I had to nail my exposure and shoot when the light was coloring the landscape just right, but it was worth the technical peculiarities. The colors soared! I now had a way to relate my images to those I had seen in magazines. Of course, the content of the images trumped everything—you have to have that—but now I was given a way to start really thinking about the final image and what it was going to say as a whole.

Content, light, contrast, color—they are all part of pulling together a compelling image. Black-and-white images can certainly be moving. I enjoy stripping color from a shot to declutter the image, and there's not a shred of doubt that many of the world's most powerful images were shot in black and white.

FIGURE 1.1 A shot from my first roll of Fujichrome Velvia, which really turned my head with its color rendering versus other film stocks I had been using.

ISO 100, 1/60 sec., f/5.6, 90mm lens

FIGURE 1.2 The colors of the United States flag may have had no initial meaning, but each has taken on symbolic value: red for bravery, white for purity, and blue for justice and stability (opposite page).

ISO 200, 1/125 sec., f/1.4, 35mm lens

Imagine, though, just for a minute, not even having the opportunity or the ability to shoot in color. Keep in mind that early photography was technologically relegated to monochromatic image making. For several decades, photographers could only shoot in shades of gray. When color film came into the picture, many of the images we saw published in the press were still black and white, because processing black and white was more efficient and safer.

Fast-forward to the digital era. Shooting, or rather processing, in black and white is a choice. A good one in many cases, but a choice nonetheless. A choice that did not exist until recently. Think about what old black-and-white shots would look like if they were in color. Would they be more interesting? Would they lose some of their value?

Even more intriguing, consider what the photographers who made those old shots would think about shooting in color. What if those photographers who predated color film had the same capabilities we have today? I'm going to put my leg out on a limb and argue that some of them would agree with those colorful aspirations of the famous quote above from our friend Daguerre. Along with Joseph Niépce, the man who was closest to the inception of photography as we know it, Daguerre was innovative enough to aspire for color. No, the world was not black and white before color television. It was just as excitingly colorful as it is today. All we needed was a way to capture it.

All right, now that I've stirred up the hornet's nest, let's delve deeper into the reason you picked up this book.

A UNIVERSAL LANGUAGE

To put it simply, color is powerful and ubiquitous. Take a look around the world. It's full of color. An elementary observation, I know, but it can also be easily forgotten. Color conveys understanding on many levels.

Color Is Cultural

Think about those colors that represent your country or society. If you live in the United States or France, the colors red, white, and blue hold a special, different cultural meaning than other combinations of colors (**FIGURE 1.2**). There is meaning in those colors—a specific one for each, in fact—that goes beyond universal interpretation.

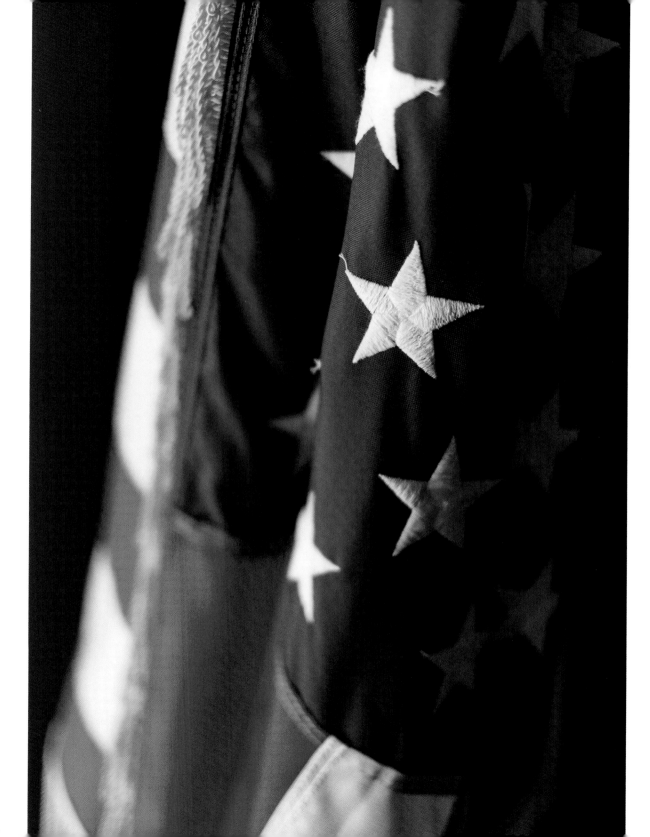

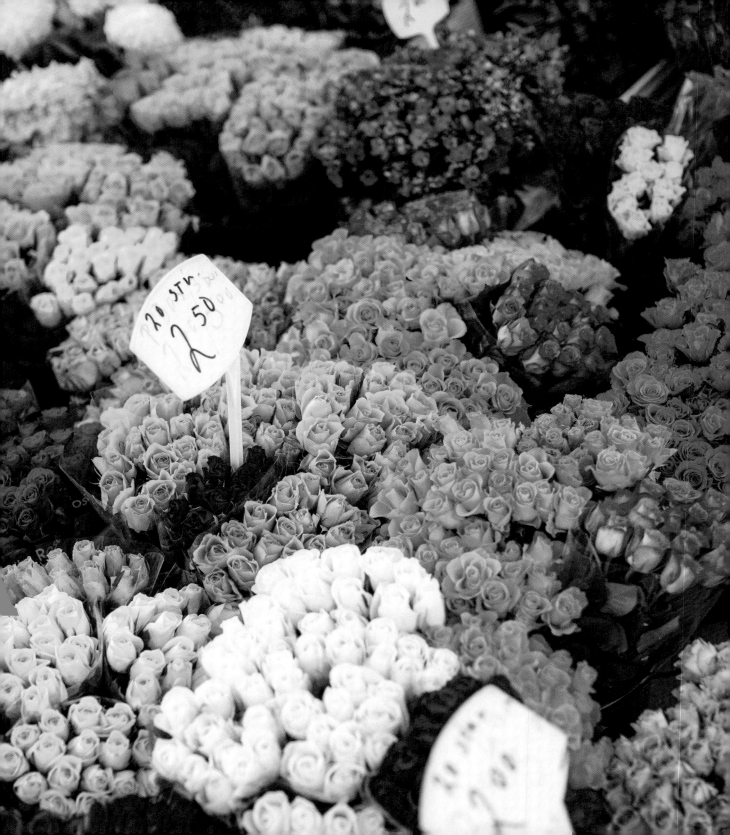

Take this one more step and consider the colors of clothing you see among certain populations. It sounds stereotypical, but I expect the area of the world in which I live, an agricultural part of the American southern plains, to be inundated with clothing that uses muted earth tones, such as browns and greens. Yet I'm not too far from Chihuahua, Mexico, where specific elements of iconic clothing are also paired with bright colors, such as yellows, blues, greens, and even pinks. Being from a small town and raised on a Texas ranch, I was at first amused by the sight of lime green formal cowboy boots in a Chihuahua department store, but it was soon apparent that I was just taking in an important part of the culture in which I was simply a visitor.

I'm not saying people of every culture around the world are relegated to wearing a few colors only, but when you start thinking about what represents the population of a country, you might abstractly think about the colors that they are often wearing. And of course, much of what we know about this comes from the photographs that we see in a variety of publications.

Color Is Emotional

As we'll discuss later in the book, color is very personal, but we have assigned specific emotions to dominant colors that we see. Red often represents anger or boldness, yellow represents happiness, and blue represents peacefulness. What is your favorite color? How does it make you feel? How important is that color to you? These are just a few questions you can ask yourself that reveal how emotional color can be.

People who comment on a certain color in an image because they find something in it that strikes a chord always intrigue me, especially if it is a color I previously had not noticed or given much attention. Little slices of a different color in a sunset introduce a new element into the shot, as well as a potential emotional trigger. Designers select colors to use in advertisements based on what they say about the product and how they say it. If you are in the advertising world, then you know just how smart people can be about color. Every individual reacts to color, however, whether it is used intentionally or happened upon and documented (**FIGURE 1.3**).

FIGURE 1.3 **A Dutch flower market is a visual treat for our eyes and brains, which respond to all of the colors in this palette of petals.**

ISO 100, 1/1000 sec., f/2, 50mm lens

Color Is Physiological

Our bodies respond to color. More specifically, our eyes and brain do most of the responding. These reactions influence how color is used and sought out by image producers and users. Objectively, colors like red and orange are physically more attractive than purples and dark greens. They hit our eyes before the rest of the colors in an image do, meaning we physiologically respond more quickly to them. How quickly? According to my friend and colleague Justin Keene, a psychophysiological researcher at Texas Tech University, 350 milliseconds pass from the time information hits the retina and is transferred to the visual cortex. Yes. *That* quickly. Hence the term "color pop."

This is the mechanical facet of color, and it helps us photographers determine how to compose images and draw the viewer's attention. The physiological part of color is less about meaning and emotional content and more about the nuts and bolts. Nonetheless, the nuts and bolts are worth acknowledging.

All of it is important, though. Color is as much a part of who we are as our own personalities and style. It indicates to us everything from the state of the land we stand upon to the mood of the room we inhabit and the person with whom we are talking. How we consume color and how we interpret it make up a great deal of the visual language. Colors may hold different meanings for different cultures—even for different people across the same culture—but one thing for sure is that color is read like other visual elements. As photographers, we ought to consider how color affects and strengthens our images and be intentional about its use as we speak that visual language.

A VITAL PART OF STORYTELLING

When I was in Spain a few years ago, I photographed everything. I was interested in the history, the people, the places, the food—you name it. I was there for a few weeks, and I wanted to use photography as a way to understand the country and as a way to gain entrée into its culture. It was immediately clear that color matters a great deal to the people of Spain, and has for centuries. Traditional clothing, particularly female formal dresses, is extremely colorful, and much of the architecture sports colorful accents, even in older parts of cities in Andalucia, where many buildings are white due to the summer heat. The colors of the Spanish culture were vibrant, energetic, and immediately attractive. It wasn't as if everything was bright orange, neon blue, or fire

engine red, but the moment I saw a color that stood out because of its ties to the nation's heritage and culture, I was hooked, both visually and photographically. It was *imperative* that those colors that really stood out were photographed, because they told a part of the story of Spain (**FIGURE 1.4**, **FIGURE 1.5**).

FIGURE 1.4 The signature Spanish coloration of older buildings and architecture in Triana.
ISO 100, 1/80 sec., f/16, 80mm lens

FIGURE 1.5 Processional color caught with a wink! Although traditional formal clothing for men is rather conservative, female dress is vibrantly extravagant.

ISO 100, 1/80 sec., f/16, 80mm lens

Color is dynamic, and it (or the lack of it) is an essential part of setting the tone of a story and seeing that story unfold. Just as different types of shots help add variety and dynamic value to a photo essay, the colors in those shots are important in tempering its mood. A story about summer fun isn't much without bright colors, yet you typically wouldn't find such colors in stories shot at other times of the year. Likewise, storytelling images benefit from the directive use of color, where a slash of color leads the eye or frames the subject.

At other times, it is important that color doesn't get in the way but simply plays a filler role when it comes to the overall significance of any individual shot. Muted, desaturated colors—often achieved in post-processing—paint a darker ambience for some images, where as vibrant and saturated colors are playful and uplifting. Both ends of the spectrum quickly and powerfully dictate an emotion to the image's viewer when taking it all in.

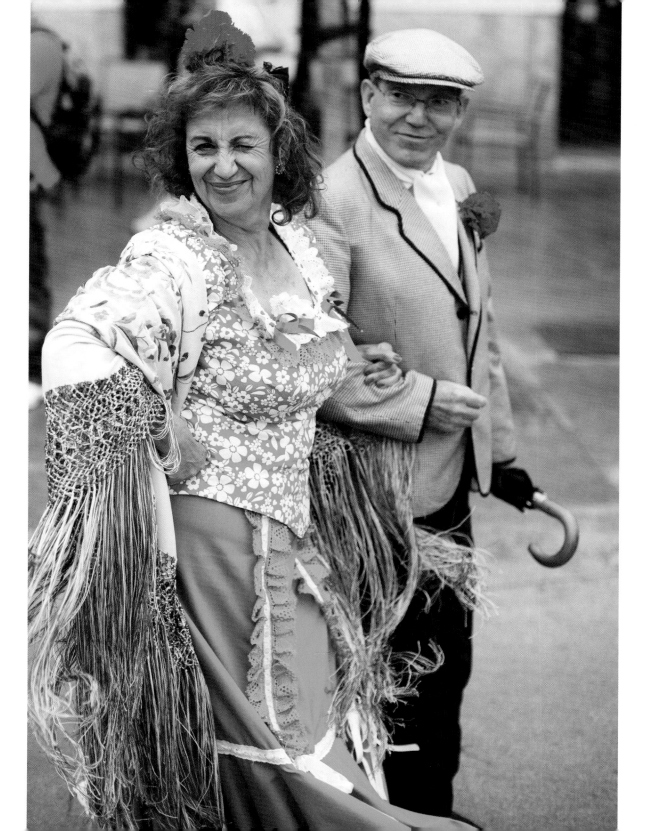

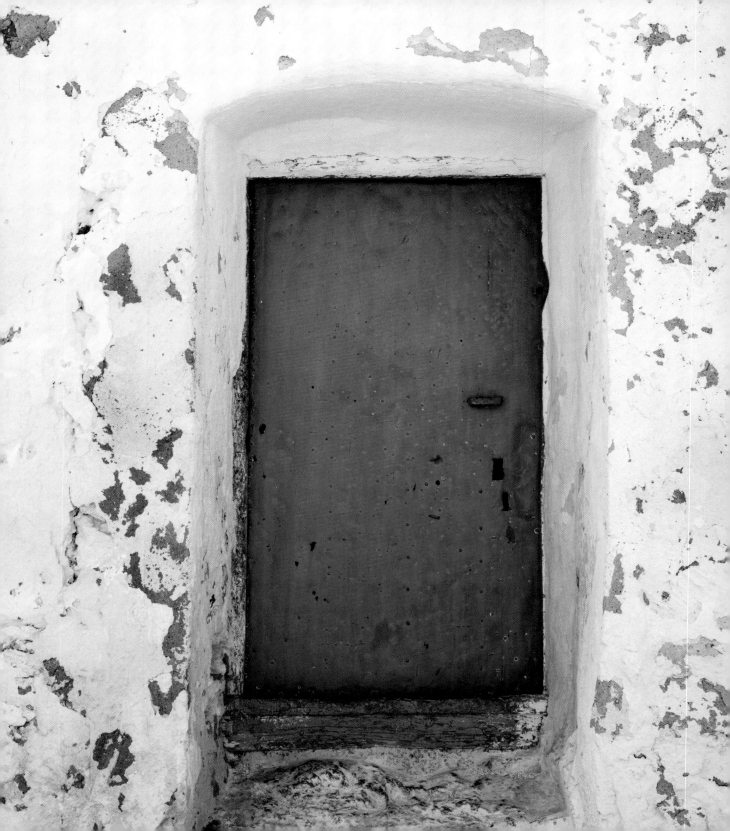

The Subjectivity of Color

You have understood color ever since you learned the names of colors as a youngster, right? What more is there to get? Plenty!

Color in photographs can evoke emotion and other reactions, so it's worth understanding how color physically grabs the photographer's and the viewer's attention and then putting that knowledge to use. This chapter briefly highlights how color is perceived—from objective to subjective perspectives—and why the science behind color is important to photographers.

ISO 100, 1/50 sec., f/16, 50mm lens

THREE WAYS OF UNDERSTANDING COLOR

Just think, color photography didn't arrive until the latter half of the 19th century, after physicist James Clerk Maxwell revealed a color photograph of a tartan ribbon to an astute group of colleagues. Scientists, artists, and others, however, have thought about, theorized about, and explored color for centuries. Paul Martin Lester explains how color has been conceived through the ages in his popular book *Visual Communication: Images with Messages*; let's delve into these ideas as they pertain to photography.

The Science

The first way we can understand color is by looking at the science behind the way we actually see it. (Don't worry, it's not going to be too dry—and it might actually be fun.) This objective way of understanding color highlights how it exists along the visible part of the electromagnetic spectrum, and as a result, how we are able to measure the wavelengths and frequencies of each color.

What does this mean? It means that visually warmer colors that have longer wavelengths, such as reds and oranges, are discernable much more quickly than cooler colors, such as light and dark blues (**FIGURE 2.1**). In the scheme of all things visual, reds do not reach the eye *exponentially* faster, but in relative terms—relative in that the wavelength difference between red and blue is only about 125 nanometers—it is a great distance. It's little wonder that stop signs, yield signs, and other warning signage and labels use more aggressive, warm colors (**FIGURE 2.2**).

FIGURE 2.1 A sunset like this one shows how colors reach the eye. The warmer oranges and yellows at the horizon hit the eye faster and are therefore seen before the colors that have shorter wavelengths, such as the indigos and dark blues further up.

ISO 200, 1/250 sec., f/4, 200mm lens

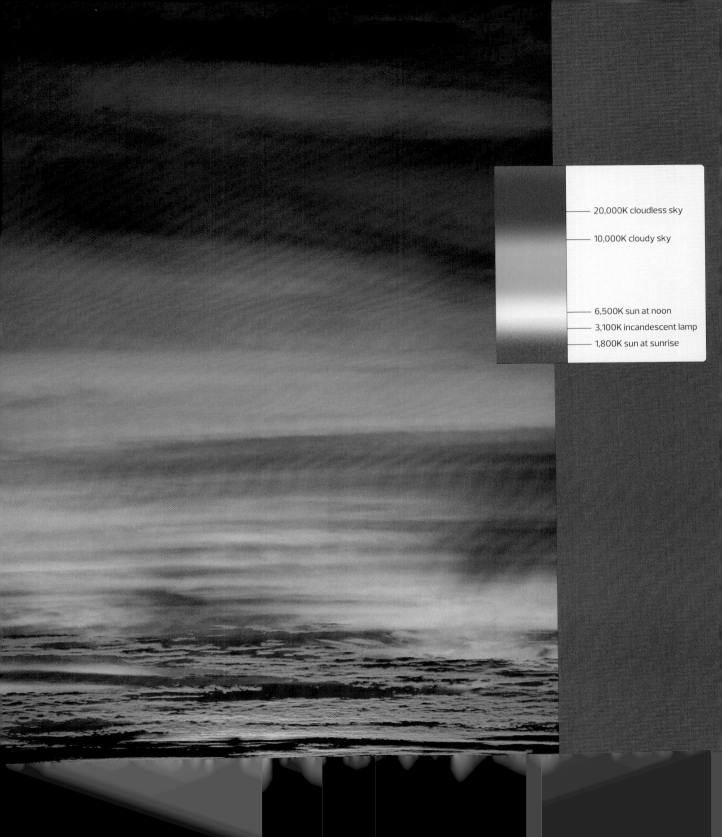

20,000K cloudless sky

10,000K cloudy sky

6,500K sun at noon

3,100K incandescent lamp

1,800K sun at sunrise

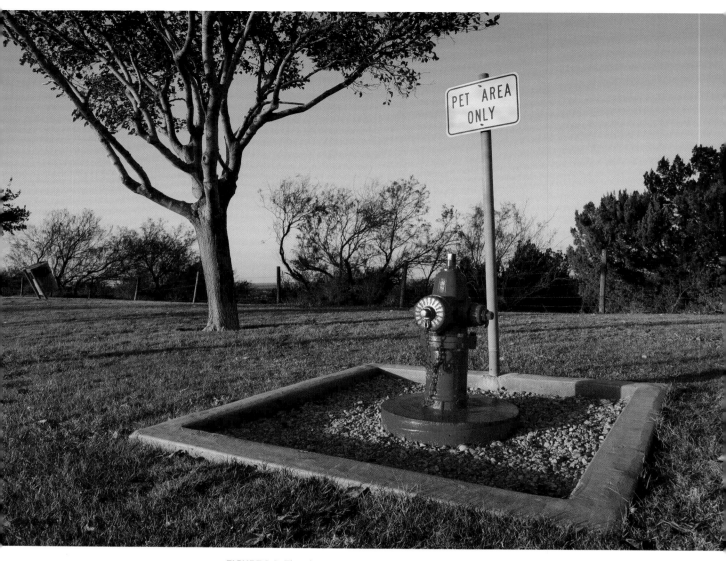

FIGURE 2.2 The placement and purpose for this fire hydrant may be comical, but the bright, reaching red used to paint hydrants elsewhere is intentional. You would not want a fire truck to miss one when it mattered!

ISO 100, 1/640 sec., f/5, 16mm lens

THE WAY WE TALK ABOUT COLOR TEMPERATURE

Another way we can understand color scientifically is by measuring its temperature. If you are fairly new to photography, you may not be familiar with the term *color temperature*. Every color has a temperature, so to speak, and it is measured on the Kelvin (K) scale. (This is why we describe white balance using the Kelvin scale.) However, our descriptions of color temperatures can be deceiving. We describe colors as being warmer or cooler visually. Reds and oranges are perceived as warmer colors, whereas blues are cooler. The actual temperatures of these colors, however, are quite the opposite.

Picture a gas flame on a stove. The tip of the flame is reddish orange, but if you look closer to the burner, you will see blue where the flame begins. If you were to touch that flame, the blue part of it would be hotter than the red (don't try this at home, please). Whereas a candle flame has a color temperature of about 1,000K, a completely blue northern sky can be upwards of 10,000K. Technically, calling blue "cooler" goes against the science of it all.

Just so we are all on the same page, you will rarely hear a photographer describe the way a color *looks* according to the Kelvin scale. It makes sense to call reds warm and blues cool. The temperature of colors comes into play more when adjusting white balance, which we discuss in Chapter 8.

Real–World Comparison

The second way we can understand color, and the way we start to make sense of it in a real-world environment, is by comparing specific colors to things around us. This is probably how you were taught colors in the first place. We learn the color red by looking at pictures of apples and the color orange by, well, looking at oranges. Seems pretty simple.

But have you ever attempted to describe a color to someone who has never seen it? Better yet, how do you teach a child a color (**FIGURE 2.3**)? The easiest and the most effective way of doing so is to compare it to something that the child already knows about: It's red, like an apple. Saying the color of any given object is as blue as the ocean on a sunny day depicts a particular type of blue—not the same blue as a flower or a butterfly, but rather the ocean (**FIGURE 2.4**). Descriptive comparison educates us about a color, and it is also helpful in exploring new ones.

Subjective Analysis

The final way color is understood is through subjective analysis. Of the three, this is the least scientific way of understanding color; it is completely, unobjectively human. And guess what? It is the ultimate way of understanding color. Without consciously doing so, it takes into account the previous two ways to discern color, references them, and then adds that special something we call *interpretation* (**FIGURE 2.5**). We'll cover this in much more detail elsewhere: Chapters 5 and 6 are all about how color appeals to our emotions and distinguishes the people and places of the world—all because of the subjective, yet deeply meaningful, interpretation of color.

These three ways of understanding color are not mutually exclusive. In fact, they are intertwined. To take one away would be to do away with years' worth of knowledge on the subject of human emotion, judgment, and culture.

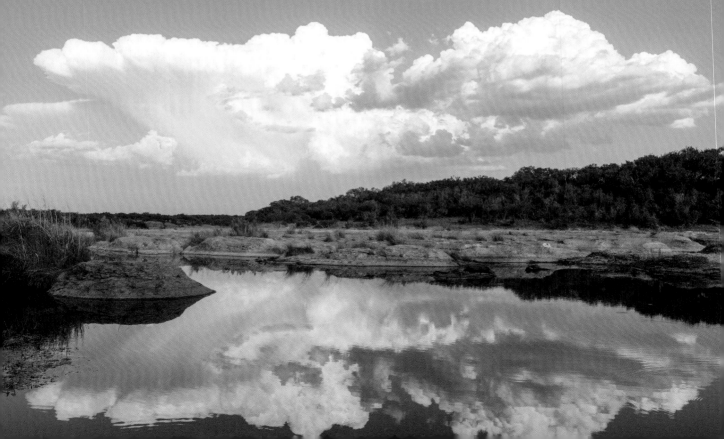

FIGURE 2.3 We once compared red to an apple, and my 18-month-old daughter now calls everything red and round an apple, even tomatoes (opposite page, top).

ISO 400, 1/125 sec., f/8, 50mm lens

FIGURE 2.4 Comparing the color blue to water is common, but we often compare that blue to the color of the sky, too—and the sky is what gives water such color (opposite page, bottom).

ISO 200, 1/125 sec., f/16, 28mm lens

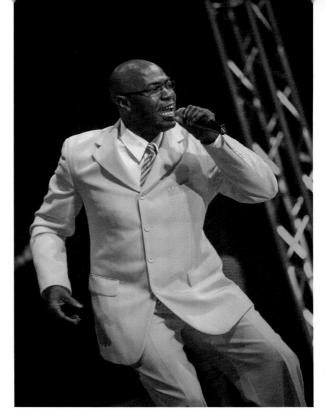

FIGURE 2.5 Orange is an energetic color, usually adding excitement and positivity to an image or environment. In the case of this entertainer, orange was a solid pick.

ISO 1600, 1/640 sec., f/2.8, 145mm lens

WHY THE SCIENCE IS IMPORTANT

I don't want to spend too much time harping on just how crucial it is for photographers to know *how* we physically see, but just imagine that you are given a direct line to the brain through which you can pass all of the photographic goodness you create. There's only one way you can do that, and it's through the eyes. An almost instantaneous response after our vision is stimulated puts the brain to work. The eye itself works like a camera—more accurately, a camera works very similarly to the eye—and it is the gateway for mentally processing the information that passes through it via light.

At the back of the eye lies the retina, which contains over 120 million photoreceptors called rods and cones. You could say these photoreceptors are the anatomical equivalent to film or the digital sensor in the back of your camera. The much more numerous rods are responsible for our vision in the dark, as well as our ability to see white, black, and gray. We who are in search of knowledge about color, though, are more interested in the cones.

The cones are what enable us to see color, as well as detail and everything that comes along with contrast, such as movement and changes in light values and conditions. Cones are sensitive to three primary colors—red, green, and blue—which when added together in various combinations or levels make up all of the colors of the visible part of the electromagnetic spectrum. Many experts estimate that the human eye can perceive some 10 million different colors. Although being able to actually distinguish those colors from one another might be tricky, we can agree that our eyes are extremely amazing organs.

Photoreceptors known as rods and cones allow the eye to physically detect light, shadow, and color. The far less numerous cones are responsible for our ability to see color (courtesy of iStock).

Hold on, though, we're not done outlining the process of seeing colors yet. The light that passes through the intricacies of the eye is converted to a signal that is channeled down the optic nerve, through the thalamus, and ultimately to the visual cortex, the component of the brain where visual information is processed and distributed to other parts of the body. Here is where visual information begins to make sense to us personally. The signal from our eyes is now meaningful on a variety of levels in our brain—and in our *mind*. Our eyes perform the process of seeing, but that process is not complete until we cognitively render that information into something useful to us. In this case, part of that usefulness is seeing color.

Taking Science to the Street

So why as photographers should we care about this brief physiological explanation of how the eyes work with the brain in order for us to *see*? Because the physical act of seeing is inseparable from the mental act of seeing. The following two chapters discuss how color provokes the attention of the viewer's eyes, and much of what is highlighted actually depends upon how our eyes initially respond to color values. Although the brain engages our understanding of content and perhaps the *why* behind choices the photographer makes, things like using color to compose the frame or visually highlight forms in a shot depend quite a bit on the eyes' first reaction (**FIGURE 2.6**).

Ultimately, knowing a bit of the science behind seeing color is simply part of knowing your tools inside and out. You have a camera and you know how to put it to use. You know every function, every button (well, at least a lot of them), and hopefully you've figured out how to turn that beeping off when the camera autofocuses. The knowledge you have about your camera is second nature, filed away in the back of your head, quickly accessed the moment you encounter a situation that poses the need for some "figuring," if you will. Consider this extra bit of knowledge about wavelengths, color temperature, and vision something else you can add to that cache of applicable information. The next time you see the color red in your frame, you might consider more strongly where it is, if it poses a distraction, or if it needs to be given more credence due to its part in a significant subject in the shot. Whether it is important for your viewer to notice that red or not, this type of knowledge allows you to take more control over your frame. In the end, this leads to stronger images, and that's what we're all about, isn't it?

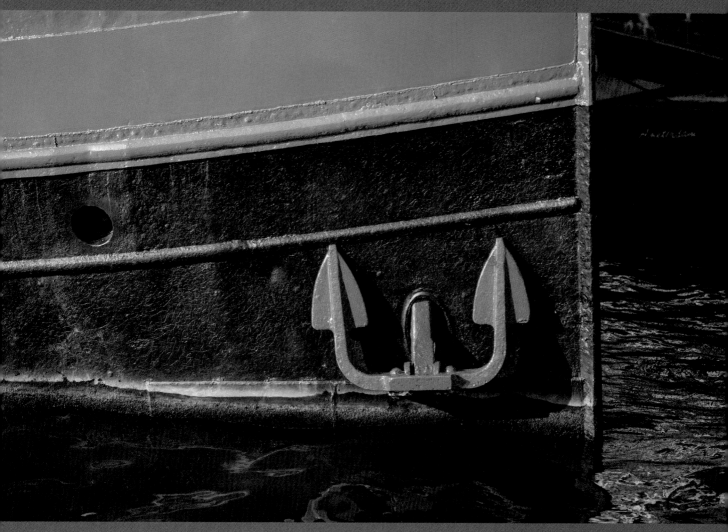

FIGURE 2.6 The most important and revealing subject in the shot happens to be the anchor. A cooler color would not have drawn the eye as strongly, particularly in conjunction with the other colors in the image.

ISO 100, 1/400 sec., f/4, 200mm lens

ISO 100, 1/640 sec., f/4, 24–105mm lens

Color in the Frame

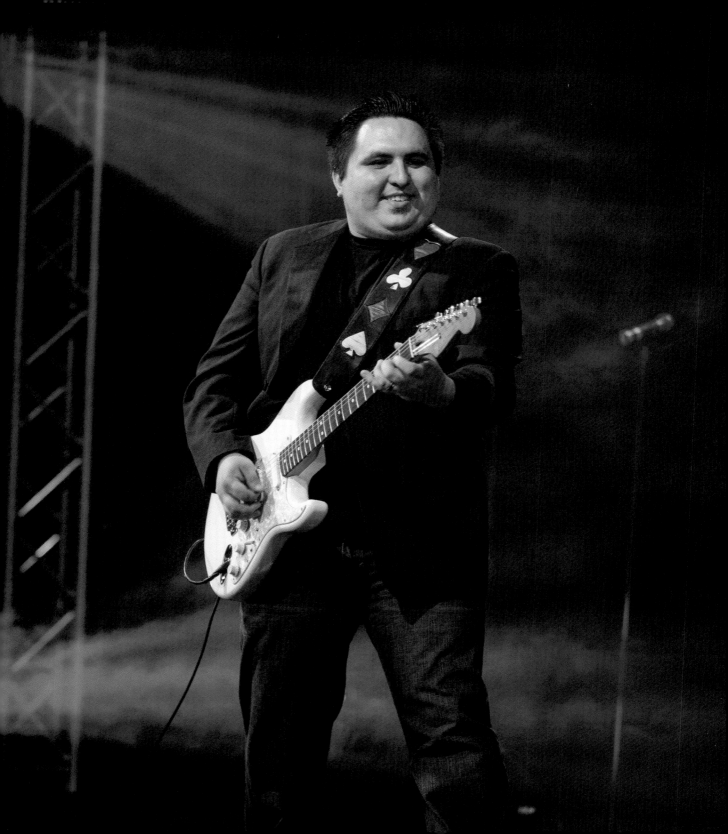

Guiding the Eye with Color

Guiding the eye with color. It sounds forceful, directive, and authoritative. Break it down—*guiding the eye*—and it sounds like a term we in the photography world are sometimes hesitant to use: *manipulation*. But that is what we do. We manipulate the direction that a viewer's eyes go in our images. We suggest to them where they should look, what content is important, and in some cases, how to get out of the photograph. Knowing what you know from Chapter 2, "The Subjectivity of Color," you already have a good idea of how we can use color to attract visual attention. It's now time to lead that eye with color.

ISO 800, 1/200 sec., f/2.8, 100mm lens

Keep in mind that color is only one part of the equation that helps you do this, but if we're diligent in assessing color in our frame, noticing how it provides us pathways or visual destinations in an environment, we can really exploit that nuance of strong imagery.

COLOR = LIGHT

If you ever sit in on a class of mine that introduces concepts of light for photography, you'll hear me say that my favorite aspect of light is actually shadow. Shadows are actually what give subject matter in our shots depth and tangibility. Without the transition from light to shadow, whether it is gradual or hard, images seem flat and unengaging. Shadows give us texture and as much of a three-dimensional quality as we're going to get using a two-dimensional means of creating imagery.

My second favorite component of light is color. Light is made up of all of the colors in the electromagnetic spectrum. When light hits an object, either an inanimate *thing* or a living being, that object reflects and absorbs certain amounts of that light, which is translated as a color. Therefore, color is part of both light *and* shadow, and when comparing it to what shadows offer us visually, we start to see similarities. Creating visual depth with color is what the next chapter is all about, but think about how light alone makes color interesting and engaging.

Bright colors that pop indicate intense reflection of light, whereas dark colors soak up more light and are often moody in personality. There is a continuum in between that engages a viewer's eyes variably. Picture the color red. Just the color, nothing else. The more intense the light, the easier it is for our eyes to notice the color, although it might be more difficult to look at it for long. That same color in the shade, where it reflects less direct light, becomes more subdued. If the reflection is too low, it becomes difficult to see, and at some point, it becomes indiscernible as a color altogether (**FIGURE 3.1**). This is why it is often hard to notice subtle colors mixed in with others, such as yellows among greens, different hues of violets, and so forth.

Luminance, therefore, is one of the key considerations when using color and colorful subject matter to lead the eye. Brighter colors seek out attention more than others do. This seems like common sense, but when something is as easily taken for granted as light and color are, keeping this principle in mind means we can use it to our advantage.

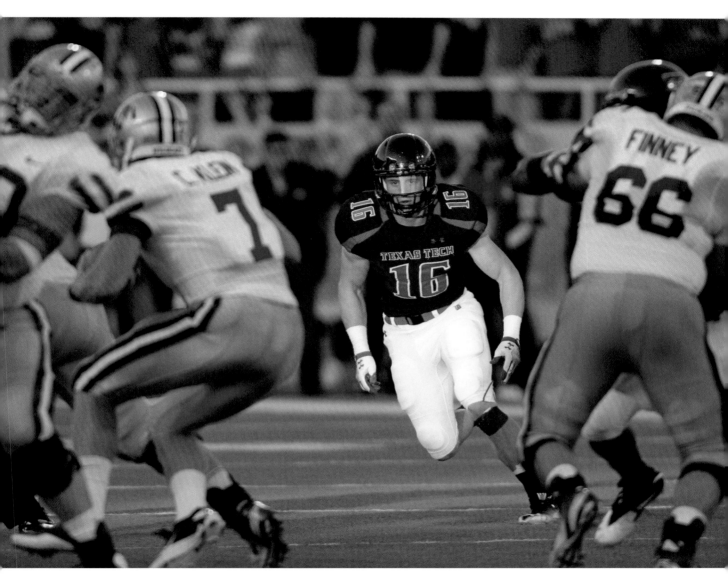

FIGURE 3.1 When this football player hit the shaft of light coming around the west side of the stadium, the reds on his uniform exploded compared with the other colors in the shadows.

ISO 400, 1/1250 sec., f/2.8, 400mm lens

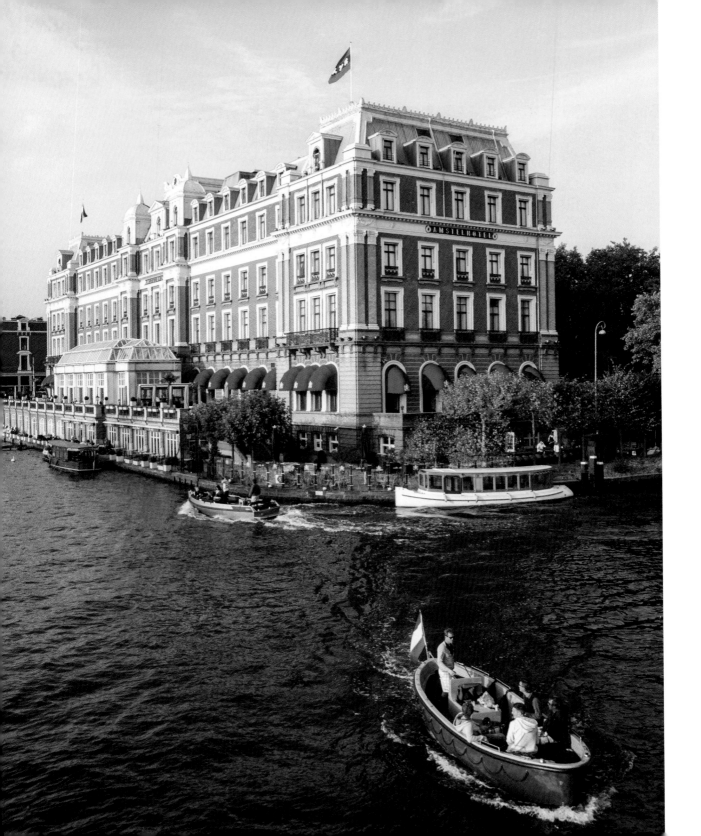

SMALL COLOR, LARGE COLOR

When you browse through wedding photography online, every now and then you will come across a shot of a bride holding a bouquet of flowers. The bride is shot from just below the waist, and like many nice bridal portraits, the shallow depth of field is pleasing. The photograph is black and white, except for the flowers: yellow daisies. Held at her waist, their yellow petals take up just a small portion of the lower part of the frame. However, they are immediately noticeable. You either love or hate selective color like this, as trendy as it might be, but you have to admit that a small, single dose of color catches your attention.

Small Dots of Color

If we think abstractly about that small amount of the frame that was left colorful in the previous example, we're essentially looking at a dot. Well, something bigger than the usual dot, but a dot in that there is a relatively singular point or small area of color that is extremely different than the coloration of the rest of the image. Compositionally, dots draw the eye strongly, and they are some of the most recognizable forms our brains encounter upon seeing. If you shoot a silhouette of a lone tree on the horizon, it's simply a dot against the sky—and that's likely where a viewer's eyes are going first. Likewise, a small area of color—particularly an intense or bright one—will attract the eye (**FIGURE 3.2**). Depending on what you want from your image, this can be a good or a bad thing: good if you want your viewers to easily find their way to an important subject in the frame, bad if that color becomes a distraction from the subject (**FIGURE 3.3**).

FIGURE 3.3 Be cautious of colors in the frame that can potentially take away from the critical subject matter, such as the overly bright reds, whites, and oranges in the top left corner of this image.

ISO 400, 1/1000 sec., f/2.8, 200mm lens

FIGURE 3.2 The red canopies above the windows of this hotel in Amsterdam are like bright, attractive dots that bring our eyes quickly to the image's main subject (opposite page).

ISO 200, 1/80 sec., f/10, 21mm lens

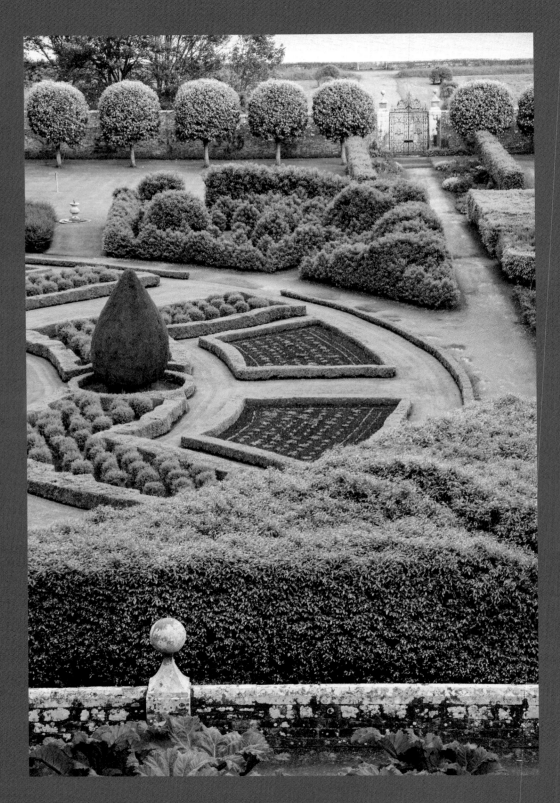

FIGURE 3.4 A garden fit for a king. Greens dominate this Scottish Highlands garden on the North Sea.

ISO 200, 1/60 sec., f/8, 105mm lens

Large Areas of Color

So, if dots or small areas of color gain attention immediately, what about large areas of consistent color? If a single color dominates the frame, you're going to see it (**FIGURE 3.4**). What is it good for, though?

For one, it is a great way to simplify your shot. As we'll discuss in the next chapter, increasing the simplicity of a shot affords both the creator and the viewer easier visual access into the shot and the important content. Zoom in and tighten up on parts of a subject that you can compose strongly but simply, and if a specific color takes up most of the real estate, you eliminate distraction, particularly if there is an accompanying color that plays a lesser role.

Second, large amounts of color are nice for compositionally framing subject matter in your shots. Whether using a solid brick wall, a pretty doorway, or a sunset on which to silhouette your subject, solid colors immerse the subject in an uncomplicated

blanket of color (**FIGURE 3.5**). Unlike finding and using specific objects that frame your subject, you simply let the color real estate do the job. Large areas of color like this also establish mood and a sense of the story or environment in which you are shooting (more on this in Chapter 5).

Of course, small and large areas of color often work together strongly (**FIGURES 3.6** and **3.7**). Strip the color away, and you are left with a small tone of gray and a larger tone of a different shade of gray. Like trying to imagine a color world in black and white, this requires thinking more abstractly about the solid structures laid out before your camera when you are shooting. Speaking with the camera eloquently involves being keen about the way not only your eyes but the eyes of others will respond to the photograph. The use of color in Figure 3.7 is comical, yes, but the red also serves to drive attention to Coen.

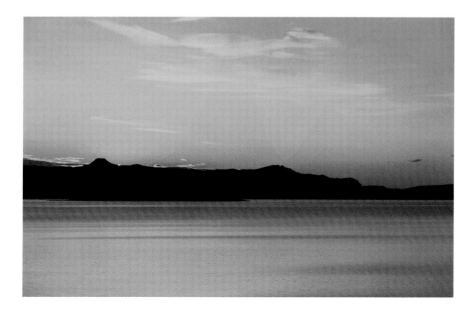

FIGURE 3.5 The pale orange color of this Isle of Skye sunset reflects on the water of the Sound of Raasay. The two areas of similar coloration make a nice backdrop for the silhouette of the mountains.

ISO 200, 1/500 sec., f/8, 145mm lens

FIGURE 3.6 Heads, the most round and dotlike form of our bodies, attract the eye in any portrait. In this image of my friends Fleur and Coen, I asked Coen to leave his helmet on to break up the palette of green (right).

ISO 400, 1/200 sec., f/2.8, 105mm lens

FIGURE 3.7 On a background of desaturated foliage, as winter touches the mountains, a lone red leaf brightly demands visual attention. Dots of color work well when the subject matter is similar throughout the image (far right).

ISO 200, 1/60 sec., f/4.5, 58mm lens

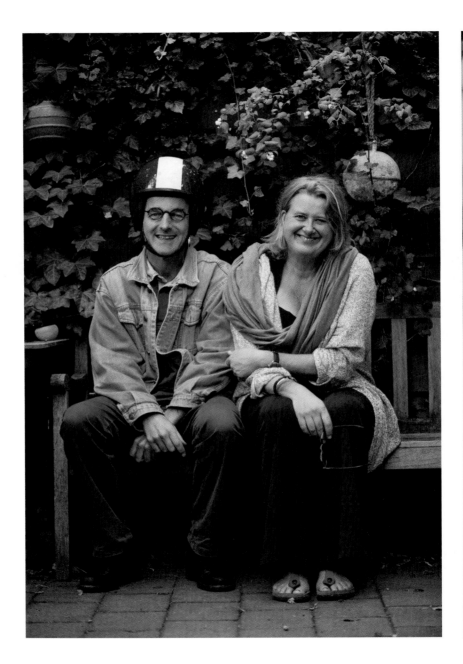

TRAINING THE EYE FOR COLOR

Are you supposed to just keep an eye out for any and all colors in your frame? Well, yes, in a way. It seems a bit meticulous, but if you train your eye to take in all the details in the shot, then you become more adept at noticing how color might affect a viewing of your photograph.

Practice seeking out small areas of color as a way to further your photographic vision. Look for colorful subject matter that stands out not because of its vastness, but rather its drop of color against another color or larger subject matter. A yellow leaf that has fallen into a black-bottom river, a green street sign against a monotonous wall of red brick, a warmly lit person against a vast, dark backdrop—all examples strongly hinged on the color in a relatively small area of the frame.

As a practice, shoot every now and then with only color in mind. Look for tension-creating amounts of color that either draw the eye to the side of a frame or serve as a central force for other subject matter or colors (**FIGURE 3.8**). In your search for strong color that surfaces in small doses, look for those areas of color that seem distracting. Study both the strengths of colorful subject matter that are in focus and the weaknesses of those that are out of focus in the background that potentially will take away from the more important parts of the frame.

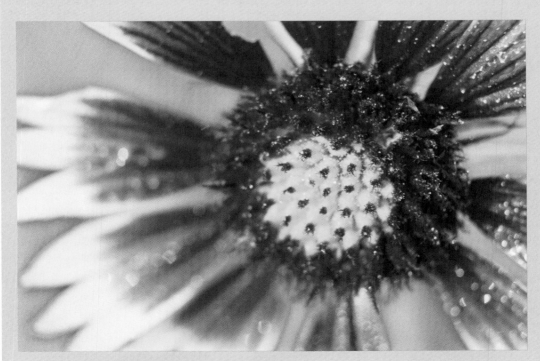

FIGURE 3.8 A photograph about finding attractive color. The bright yellow center of the flower is where all of the aggressive reds lead the eye.

ISO 100, 1/250 sec., f/4, 90mm lens with extension tubes

COMPOSING WITH COLOR

Color complements composition, and when they are used effectively together, the resulting image is that much more captivating to our viewer's eyes. Composing an image means pulling together a single, a few, or many elements in a given scene to both attract and guide an easily distracted eye through what is important in the frame. When we think about this even more simply, we're creating some order out of a variety of shapes and forms in hopes that what we end up with isn't uncomfortable to look at (unless, of course, that is *exactly* what you are going for). Add color to the mix, and we're provided another component to help us compose and excite the visual sense in our shots.

Much of the time, color and form are one and the same. Up to this point, I've talked about color rather abstractly, as if globs of solid colors were just floating through the universe. To be fair, you have to think about color that way in some cases to *see* everything that's right there in front of your camera. However, that's not how it works in the real world most of the time. In the real world, color is a part of *things*. Can you remember the last time you saw a colorless fire truck? I didn't think so.

When we talk about composing with color, we must take into account that those forms and shapes we are arranging contain color that can often strengthen and sometimes weaken a shot. Of course, weak composition is weak, regardless of the color contained within the frame. However, by following good compositional principles with an eye for color, we're able to *build* visually stimulating images. Again, our goal here is to guide the eye, and using composition that employs those colors that also attract (bright, visually stimulating colors, such as reds and yellows) accomplishes that mission.

Rule of Thirds

The first compositional concept we go to as photographers is the rule of thirds. Breaking the frame into horizontal and vertical thirds is the foundation for the way many of us look at the world through a lens. It is also a useful guide for the placement of colorful subject matter. Want to give a particularly colorful subject attention? Just give it approximately two-thirds of the image's real estate (**FIGURE 3.9**). Bring it to the foreground and let a third or less of the sky provide context to the shot. Wide-angle lenses are also useful for such composition, allowing you to not only showcase a vibrant color but also force it to perspectively leap toward the viewer from the rest of the image (**FIGURE 3.10**).

Inversely, if you see colorful layers in a landscape or among downtown buildings, use a telephoto lens to build texture and depth in your shot by compressing the distance between each color (**FIGURE 3.11**). This technique often works when the colors are similar in tone but are different in terms of luminance or hue. These layers can be structured using the rule of thirds, using each third line as a demarcation for a new color to start, or the rule can simply be used as inspiration for composing many layers together in a frame.

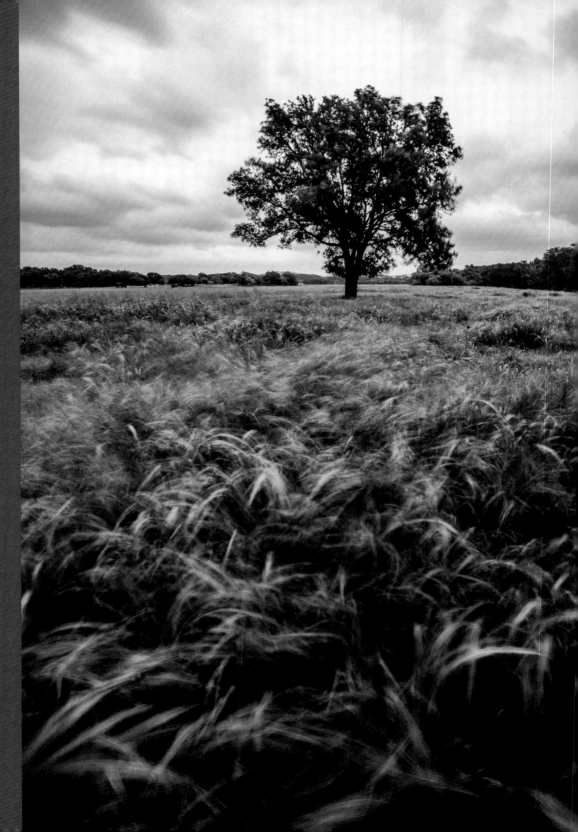

FIGURE 3.9 Low storm clouds cast a steely blue tone over the deep greens of the waving hay crop, which fills the majority of the frame for emphasis.

ISO 100, 2.5 sec., f/14, 17mm lens

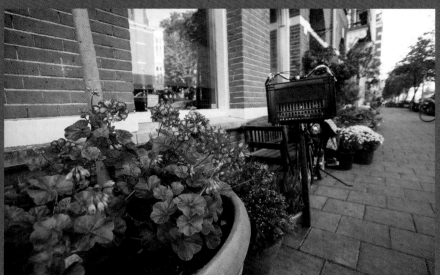

FIGURE 3.10 Getting low and close with an ultrawide angle lens expands the perspective of the shot, forcing the greens and bright reds and pinks in the foreground to strongly grab the viewer.

ISO 200, 1/80 sec., f/5.6, 17mm lens

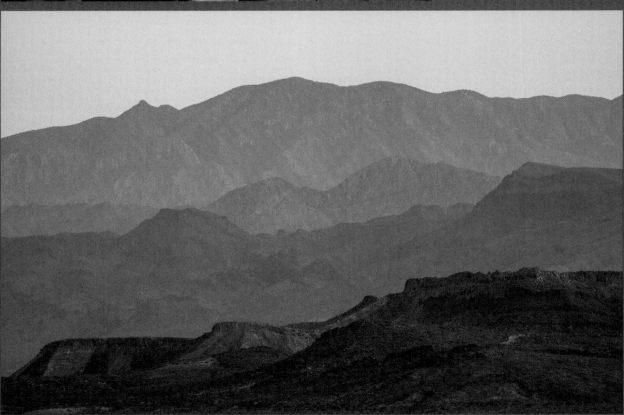

FIGURE 3.11 Landscape shooters have an eye for color, even after the sun goes down. Throwing on a long lens at twilight compresses the different blues tinting the desert mountains in northern Chihuahua, Mexico.

ISO 400, 1/80 sec., f/4, 300mm lens

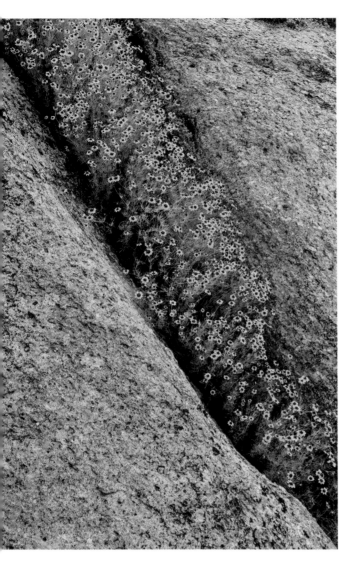

FIGURE 3.12 Leading simplicity. A strong, colorful diagonal line of black–eyed Susans cuts between two granite boulders.

ISO 800, 1/100 sec., f/8, 70mm lens

Leading Lines

Perhaps the most evident use of color for composing a photograph is in leading the eye with colorful pathways. As a form, lines are attractive enough in their own right. Absent of color, they immediately tell a viewer where to go in the frame when composed strongly. If the lines themselves are colorfully alluring, you secure the viewer's eyes that much more (**FIGURE 3.12**).

Lines that run down a road keep us in the correct lane, and there is a reason the highway department uses yellow for the lines that divide traffic (**FIGURE 3.13**). They are easily noticeable. Colors like this combined with strong leading lines keep the eyes on the road, so to speak. This book's cover employs multiple lines of budded flower petals on top of concrete steps in a Spanish park to provide distance and an eventual destination for the eyes (**FIGURE 3.14**). Lines keep the eye from searching, and colors that have longer wavelengths on the visible spectrum really lock them in.

Frame

Colorful frames are useful as well in composing a strong image. As opposed to framing using large areas of color, discussed above, using subject matter to surround, box in, or point toward significant subject matter can be strengthened when the frames themselves are of a relative color. Colorful lines can also serve as framing devices, as well as several large shapes, such as the hood, engine, and back quarter panel of two classic muscle cars that scream speed and horsepower (**FIGURE 3.15**).

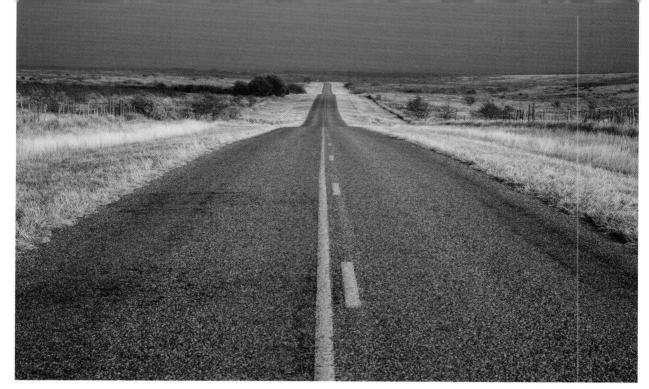

FIGURE 3.13 Many lonesome songs have been written about the open road, and a fair number of them mention that all-too-familiar yellow line. It points the way, inside and outside of this image (above).

ISO 100, 1/80 sec., f/11, 95mm lens

FIGURE 3.14 Tree blossoms cover the ground in this park in Seville, making the line the steps create more interesting as it extends into the distance (right).

ISO 400, 1/400 sec., f/2, 50mm lens

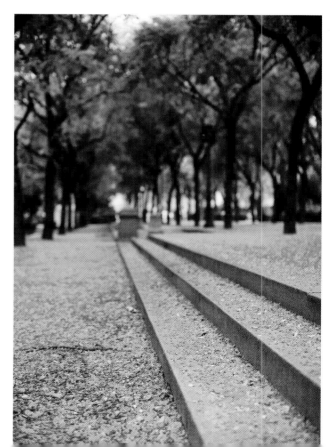

Building Colorful Images

Composing with color in mind combines that technical and physiological information you know about color with the foundational aesthetics of your photography. Seeing and composing color in a way that grabs—or *manipulates*—the viewer's attention is a smart application of both, and it simply takes being aware of color around you while you are shooting. Often, colorful images are built intentionally.

Ever since you started shooting, you have looked for better ways to create a strong image. Besides studying light, you probably started by learning composition. To really capitalize on your image making in this vein, take what you know about different colors and find how they work themselves into your work. Are your lines colorful? Is the framing device you are using to show your viewer what is important in the image distracting, or does it contribute visually?

Force yourself to think about color before you snap that wonderfully composed river scene or simple-yet-engaging shot of a fire truck at the station. Don't overlook color or take it for granted when you are shooting on the street, in the studio, or on top of the mountains.

FIGURE 3.15 The bright, speedy colored muscle cars proved to be a strong frame for their owner.

ISO 2000, 1/25 sec., f/18, 17mm lens

Create Visual Depth with Color

There's no hiding it. We photographers are working with a two-dimensional medium. We print our images on paper, and we look at them on flat digital screens. We can't reach into the image and walk through it. Luckily, our eyes are magnificent organisms, and they perceive depth and dimension.

Colors help us construct that dimension, from both a visual and a conceptual or interpretive perspective (the latter of which will be discussed in the next two chapters). Knowledge of color theory helps photographers build an eye for existing color, construct environments that use color to command the viewer's attention, and enhance a sense of dimension in an otherwise flat medium.

ISO 200, 1/50 sec., f/4, 60mm lens

A QUICK NOTE ABOUT USING COLOR THEORY

This chapter introduces certain terminology that you have probably been familiar with since elementary school. But as with most discussions of theory, color theory can be tricky to put into practice. Studio photographers or shooters who create entire environments from scratch offer examples of how to put such principles into practice, since they construct the photographic situation.

For this type of photography, much of what is about to be discussed can be put into action in any number of ways. If you're a photographer who documents what you see more than sets it up, color theory is still relevant, even if your goal is to create more naturalistic images, regardless of what color happens to be in your frame. Having a minimal understanding of color theory influences how you see the environment in which you are shooting. It helps you guide the eye of the viewer in ways that the previous chapter discusses, especially when it comes to composition.

With that being said, let's dive in, shall we?

THE COLOR WHEEL

I once heard that spending any amount of time studying color theory places you in a special club that the majority of photographers never try to join. I'm not sure how true that statement is, but I do know that color theory seems to intimidate folks, mostly because of the "T" word. I can sympathize. It's not the sexiest thing to talk or to think about. However, I do believe that having a bit of theory in your back pocket at the very least makes you a more aware photographer, whether you are shooting commercial work in the studio or photo-walking around the neighborhood.

Probably the most notable fundamental of color theory is the color wheel (**FIGURE 4.1**). This wheel is a circular depiction of all the colors in existence along a continuum, each transitioning into the colors on either side of it. Picture the color temperature graphic from the previous chapter turned into a circle where the two ends meet. That is exactly what the color wheel looks like. Clear as mud, right?

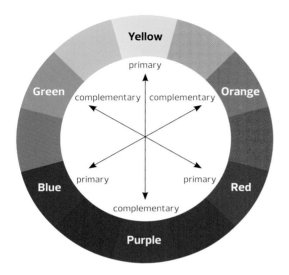

FIGURE 4.1 A traditional color wheel is composed of primary, secondary, and tertiary colors, and each color serves as the complement of the opposite color across the wheel.

Let's simplify it a bit. Think back to grade school when you first learned about color. There are three primary colors: red, blue, and yellow. This is a departure from the red, green, and blue with which we are familiar in creating digital color. We're now talking about color produced on a physical medium, be it on a wall, on a plant, or on someone's clothing. We're also talking about how color is produced on paper in a mass printing process. Now, with red, blue, and yellow as our primary colors, we can create more—called secondary colors—by mixing them together. Yellow and red produce orange, red and blue produce purple, and blue and yellow produce green. Likewise, if we mix secondary colors with primary colors, we produce tertiary colors, and so on. The point of this is that when you place red, blue, and yellow opposite each other, like you would on the points of a triangle, and in circular fashion try to fill in all of the colors in between these primaries, you will essentially be creating a color wheel.

The question, though, is: What can the color wheel tell us photographers? Quite a bit, actually. Let's consider a few more color terms.

Analogous Color

Take a look around you. More than likely, you're sitting, standing, or lying down in an environment largely made up of similar colors. If you are indoors, look at the color of the wall paint, then look at the trim paint. Notice any similarities? Better yet, if you are outdoors in nature, you are exposed to large amounts of color that tend to be the same. When we simply break it down, a lush forest is made up of a variety of greens, while a desert is made up of different reds, oranges, or yellows, or a combination of all three. These types of environments comprise *analogous colors* that for the most part are close to each other on the color wheel.

Analogous colors are naturally harmonious. They are not difficult to look at together, even if all of the colors take up similar amounts of space. In a way, analogous colors are mesmerizing, keeping you pulled into the palette, never really allowing your eye to stray too much. I love filling up the frame with analogous colors, such as layers of the landscape in the early morning (**FIGURE 4.2**) or macro textures of plants (**FIGURE 4.3**) and other materials (**FIGURE 4.4**).

Do I think about layering analogous colors when I compose these shots? Usually not consciously—it's second nature to me, and it will become second nature to you. But at times when I'm trying to make a studio image work, or when I'm simply hiking through dense grassland, it pops into my mind.

FIGURE 4.2 Layers of land in the Texas Hill Country appear as various hues of orange, all of which are analogous to each other on the theoretical color wheel.

ISO 100, 1/500 sec., f/5.6, 400mm lens

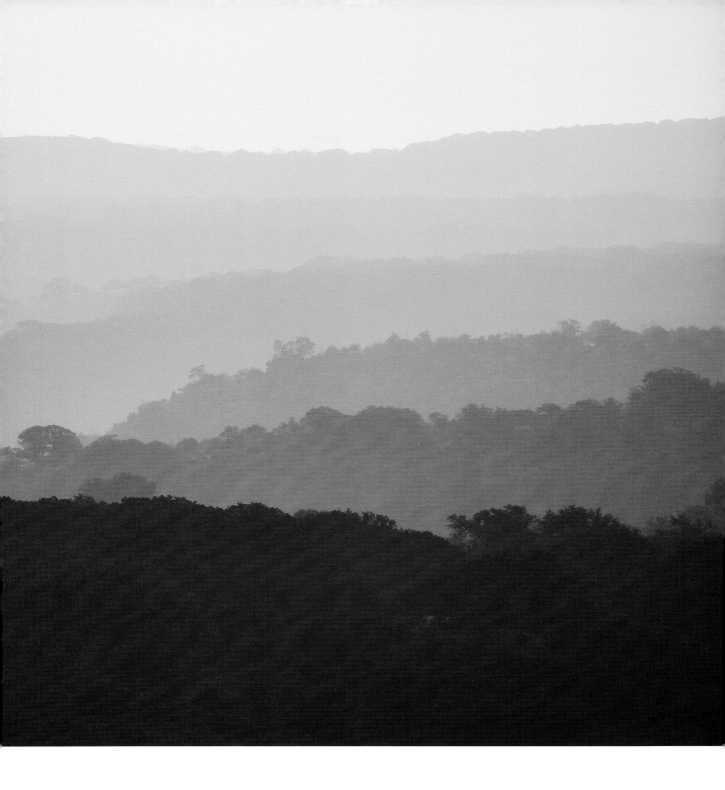

CHAPTER 4: Create Visual Depth with Color **51**

FIGURE 4.3 This lush farm field in Scotland is made up of different greens and some yellows, all tightly related colors.

ISO 100, 1/800 sec., f/2, 50mm lens

FIGURE 4.4 Finding analogous color simply takes exploration. With the exception of the obviously green bottle sticking out, the bulk of this shot is rather blue.

ISO 200, 1/320 sec., f/5.6, 35mm lens

Complementary Colors

Arguably the most recognizable and yet the most misused term in color theory is *complementary color.* Although analogous colors seem to complement each other in a scene, technically they lack the contrast to do so. Instead, when referencing the color wheel, complementary colors are those directly opposite each other, as if you were drawing a straight line from one to or through the other. For example, green is the complementary color to red, orange is the complementary color to blue (**FIGURE 4.5**), and purple is the complementary color to yellow. You'll notice that primary colors are not the complements to other primaries.

The opposition that complementary colors create becomes useful when we want something to really jump out at the viewer. We are first attracted to a particular color if it is paired well with its complement, or a color close to its complement. Blue and yellow, for example, is a popular combination of colors that are near complementary to each other (**FIGURE 4.6**). Complementary colors are said to vibrate against each other, and this vibration is often what pulls us to the two colors.

When complementary colors that are equal in intensity are placed next to each other, the line that separates them has vibrance. When you concentrate on that line, the colors seem to move back and forth in each other's space. This is more difficult to visualize when looking at one block of color next to another, but if you look at many thin lines of complementary colors put together, the vibration is easily noted.

Need a good resource for this type of effect? Google Bridget Riley, one of the most well-known artists who employ the use of vibrating colors alongside unique form.

However, complementary colors can also present visual issues. When seen in large amounts together, opposite colors can be quite jarring. With vibrance also comes the potential for dissonance. Even though they are popular around the holidays, red and green can sometimes cause visual anxiety. There's a reason that you don't often see red type on green backgrounds, or vice versa.

FIGURE 4.5 The complementary colors blue and orange found on the side of an old store wall, situated as if they were meant to oppose each other.

ISO 200. 1/1000 sec., f/4, 35mm lens

FIGURE 4.6 Even though blue and yellow are not complete opposites, the two are far enough apart to vibrate well between each other. They are also two of the most popular colors to use like this.

ISO 50, 1/200 sec., f/9, 60mm lens

Complementary colors are extremely popular in general, but you will usually see one color taking up more real estate than the other (**FIGURE 4.7**). Otherwise, the viewer might be overwhelmed. Visually, complementary colors are less harmonious than analogous colors and therefore work the eye out more. Having two equal amounts of complementary color creates tension. Experienced photographers often decide to compose in a way that relieves that tension while also directing visual attention to the most important subject matter in the shot.

FIGURE 4.7 Finding complementary colors in architecture, such as the red and green surrounding this door in Cordoba, Spain, is a matter of being observant, but one color of the two is usually minimized (green) (opposite page).

ISO 100, 1/80 sec., f/16, 60mm lens

DOMINANT AND RECESSIVE COLOR

As we discussed in the previous chapter, some colors simply demand more visual attention than others. When we look at the visual electromagnetic spectrum, colors with longer wavelengths are those that grab our attention faster than those with shorter wavelengths. Likewise, these are the colors that are "cooler" on the Kelvin scale but visually "warmer." Reds and oranges reach our eyes before blues, greens, and purples (violets). As a whole, these colors *dominate* visual attention.

SETTING THE RECORD STRAIGHT

The terms *hue, tint, shade,* and *tone* are sometimes confused or misused, so let's go over them here.

Hue is often synonymous with the word *color,* and it refers to a root designation of color that occurs on the color wheel. For example, indigo is rooted in blue; therefore, one might say it is a hue of blue. A hue is a pure color that can be affected by the other three terms: tint, shade, and tone.

Tint is created by adding white to a color. Red, for example, becomes a pastel-like pink when white is added, essentially making the original color lighter. *Tint* is not a term you hear tossed around in the photography world much.

Shade results from adding black to a particular color. Shading, thus, darkens an original color. Shade might be the most confusing term of all, since it is common to hear someone say, "I want a shade of blue," or "Let's make that red a shade lighter," when they probably mean to refer to a color's hue.

Tone refers to the addition of neutral gray to any color. The resulting color is softer than the original, and it can be said that both tinting and shading are also ways of toning colors.

All four terms are commonly used by painters, since they mix their own colors. However, knowing the vernacular of color, even if it is just inside your head, often sets your mind at the ready to see the variations and photograph them more effectively. It also makes for some dinner table trivia in case you run out of things to talk about.

For photographers, this is where seeing and being prepared for color really start to come into play. Simply put, dominant colors advance, while recessive colors, well, recede (**FIGURE 4.8**). Dominant colors are bold and engaging, much like the primary colors on the color wheel. However, the degree to which a color has dominance is determined by the color or colors with which it is combined. Picture the two colors blue and yellow, both primary on the color wheel. In any amount, pure yellow will always hit the eye before pure blue (**FIGURE 4.9**). Pure red is simply one of those colors that dominates just about anything.

Often, dominant colors are minimized in architecture and clothing, acting as accent colors. Depending on which color is used, some dominant ones can take

FIGURE 4.8 The red chair dominates the light and dark greens behind it, strongly pushing the main subject of the shot—the girl in the white dress—to the front of the shot.

ISO 200, 1/200 sec., f/2.8, 110mm lens

away from an environment, and subsequently an image, by increasing the amount of visual anxiety a viewer experiences (**FIGURE 4.10**). In many cases, dominant colors are provided less real estate in a photographic frame for just this reason. There is no rigid rule about this, though—it is an aesthetic choice, not doctrine.

The science behind dominant colors isn't necessarily anything new to you, considering the information in the previous chapter, but it is not the only thing

FIGURE 4.9 The color and the texture in the winter sky are visually interesting, but the yellow and gold in the grasses advance toward our eyes faster, technically providing the color-layered shot depth.

ISO 100, 1/40 sec., f/10, 17mm lens

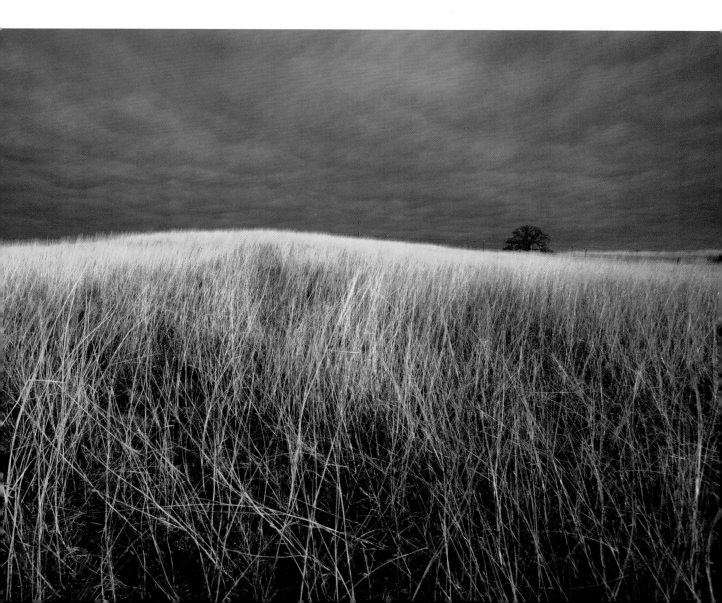

FIGURE 4.10 The yellow reflections and warmer colors making up the patina of the woodwork in this Spanish cathedral are overridden by the extremely bright and distractive yellow in the sculpted stonework behind it (above).

ISO 800, 1/30 sec., f/4, 40mm lens

FIGURE 4.11 Red is one of the strongest colors. The large amount of red wall present in the frame behind the guitarist "casts" a red glaze over the entire image (right).

ISO 200, 1/30 sec., f/2.8, 70mm lens

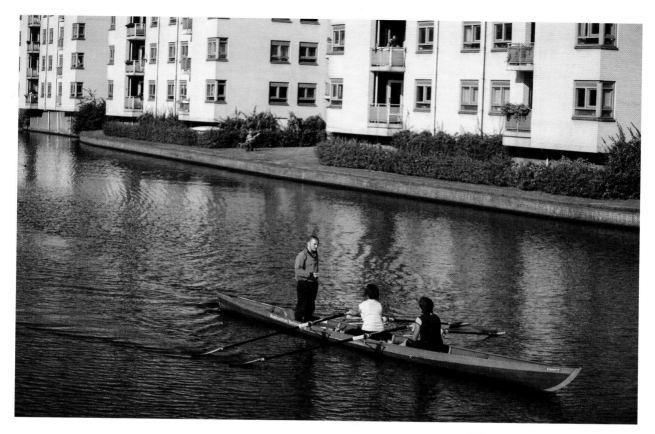

FIGURE 4.12 The dominating orange of the boat and coach advances off of the blues and browns in the water, and it works as a strong foreground color in this encompassing frame of the environment.

ISO 100, 1/2000 sec., f/2.8, 70mm lens

worth considering about dominant and recessive colors either. Dominant colors also tend to influence the perception of color around them. A lot of red in a frame might deceive our eyes into thinking other colors in the image also contain more red (**FIGURE 4.11**). A large blue sky taking up three-quarters or more of an image may cool down other colors, such as greens and browns. Certain colorcasts that might be perceived simply may be the result of one dominant color in the frame.

This is useful information when it comes to composing photographs, particularly those with a relatively large amount of subject matter that are not similar in shape or form. Dominant colors like saturated reds or bright blues might advance toward the eye from the background, but if the most important subject matter in the frame is "dressed" in such a color, compose it in the foreground to indicate its significance, both visually and as part of the image's story (**FIGURE 4.12**). The farther away this subject is in a complex frame, the less likely the viewer will find it efficiently.

FIGURE 4.13 Two colors—green and purple, a dominant and recessive color—are all that is needed to create interest in an image.

ISO 200, 1/320 sec., f/2.8, 100mm lens

FIND COLOR THEORY IN NATURE

Much of what is relevant in color theory is revealed in what we see around us. If you delve into nature photography like I do, you're privy to seeing color theory play out in the plants, the sky, the weather, and animal life. No photographer had to arrange the scene—it's simply there for the viewing. You'll see a great deal of analogous colors, such as different hues of greens and yellows in grassy plants and even among animals that blend in with their backgrounds. You'll also be able to identify colors that contrast greatly against each other, such as bright, energetic red, yellow, and orange flower petals that vibrate against darker greens, reds, and browns. Different layers of the landscape will reveal different relationships between color that we can reference with knowledge of color theory.

The next time you are out shooting nature-oriented images, spend some time concentrating on observing how basics of color theory are all around you. Key in on this imagery, and you'll appreciate working with color even more than you already do. Of course, you don't necessarily have to visit the great outdoors to study color theory with a camera in hand. You can put theory to practice in any setting! But nature has done a lot of the color composition for you and has plenty to teach about what works.

Nonetheless, using what we know about forms, such as dots, we can also strongly compose a simple image with one dominant and one recessive color. Many successful images simplify the environment in which they were made, the content in the shot, and even the technique used by the photographer. Using just two or three different colors to draw the viewer in can be very powerful, particularly if a dominant color is pushing forward meaningful subject matter (**FIGURE 4.13**).

CONTRAST

As a way to make this jaunt into color theory especially relevant for us photographers, it is probably valuable to relate it to contrast. We know contrast to be the difference between light values. Extremely full contrast is the opposition shared between complete black and complete white. To say certain colors have this much contrast is a stretch, but colors contrast because without light, they would not exist (**FIGURE 4.14**). Analogous colors contrast very little when they are of the same intensity, and complementary colors contrast quite a bit. When colors change in shade or tone, even more contrast can be introduced.

FIGURE 4.14 Like light and shadow, the simple transition in tones of the dominating gold on the goose's body provide it form, while the contrast between that gold and the blue in the water helps separate the subject from its environment (left).

ISO 400, 1/1600 sec., f/2.8, 400mm lens

FIGURE 4.15 The difference between brightly and dimly lit areas equates to a difference in the intensity of color. The contrast between Sam and the areas behind him are noticed in light and color, lending visual depth to this stacking of abstract color (below left).

ISO 200, 1/125 sec., f/2, 18mm lens

Contrast in light, or in this case, color, is a great way to create dimension in images. One of the first things to look for when you enter into any photographic situation is where the light and shadows fall. When you see shadows, you know that when they're positioned well in the frame, you can create a sense of a third dimension—depth—in the shot. Similar to the way that the difference between light and shadows builds dimension, when two contrasting colors are next to each other in a frame—they may be stacked or one may surround the other—they can contribute to the sense of depth in a shot (**FIGURE 4.15**).

SENSORY OVERLOAD

Speaking of theory, it is also important to keep in mind that sometimes color can be too much to take in adequately. We've all walked into a boutique or store that was an attack on the senses: the scent of a thousand types of potpourri wafted through the air, the store was so crowded with products that you barely had a way to get through to the counter, and the décor was so over the top that your eyes were crossing. After leaving, you might have felt you had just been to a carnival (**FIGURE 4.16**).

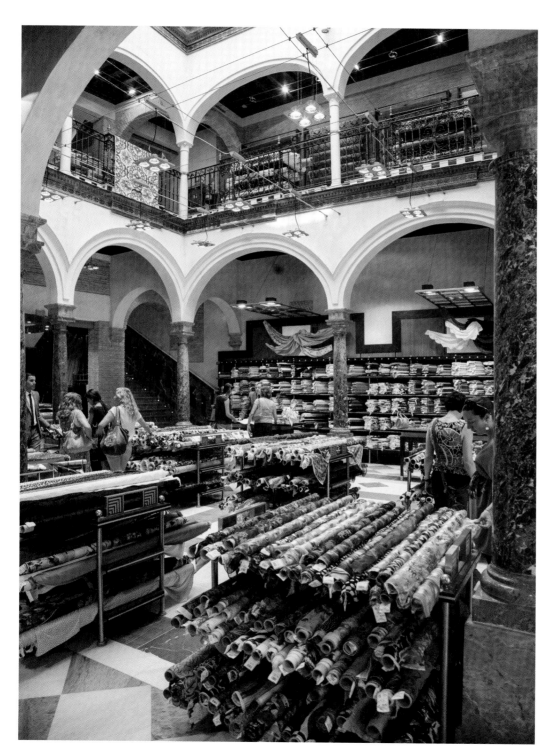

FIGURE 4.16 An upholstery store in Seville, Spain, is a visual feast of color—almost to the point of confusion.

ISO 400, 1/30 sec., f/5.6, 24mm lens

Stacking color upon different color in a frame can often be an image's downfall, especially when those colors create either too much visual vibration or contrast too much (**FIGURE 4.17**). There's no definitive amount of how much is too much. It is more of a feeling you get when shooting. More accurately, it is a feeling you get when *looking*. Often, great images are those with only a few, if only one, dominant subject matter, one dominant color, and one or two other colors that provide context and background.

This isn't to say that many colors can't go together well in a frame. When dealing with lots of colors, it might be more important to consider more strongly your composition. Colors can be harmonious, whether they are analogous *or* complementary, but they can also be visually chaotic. Chaos can be controlled, though (**FIGURE 4.18**). Think about tie-dye. Typical tie-dye contains most of the colors present on the color wheel, but it is methodical. It has a certain compositional pattern that makes it work. A lot of color is not something to shy away from, necessarily, but it helps to be fully aware of how it can be physically manipulated or composed to make an image stronger.

FIGURE 4.17 Layers and stacks of complementary, heavily vibrating colors at a popular market in Madrid can create visual dissonance.

ISO 400, 1/50 sec., f/2.8, 50mm lens

MOVING FORWARD

There is a long history of research on the creation of color and its physical and physiological effects on the human body. The past few chapters have dealt with how thinking about color mechanically can help build strong images. There's no doubt this is useful information, and seeing it successfully put to use is gratifying as an image-maker. However, the mechanics, much like everything in photography, are but one part of the image formula.

I believe nuts and bolts are necessary, and we'll never stop learning the ins and outs of our technique and the science behind what makes images technically work, but to create images with an emphasis only on the mechanics and the science is restrictive. Visual connection is also made on an emotional, interpretive level that is wrapped up in what the content of the images *means*, personally and on a social and cultural level.

From this point on, we'll bridge the gap between the science and the technical elements of color and what it powerfully does for us as photographers, and the meaning behind many colors that stand out to us on a daily basis. The next section moves from the objective to the subjective way of looking at and working with color.

FIGURE 4.18 Tulips and other extremely colorful flowers are planted each spring at the university where I teach. Although such color combinations could be excessive in other contexts, the pattern and design here make for a wonderful show of seasonal color in a semi–arid ecosystem.

ISO 400, 1/100 sec., f/16, 17mm lens

ISO 100, 1/250 sec., f/2.8, 200mm lens

The Meaning of Color

Color as Emotion

We all have a favorite color. What is yours? Think about it for a second. It's that color that, for lack of a better way of putting it, makes you feel good. It may not necessarily conjure up happiness for you, but you're at least comfortable viewing it. Emotionally, it is a pleasing color.

Your favorite color may not be someone else's pick. While science reveals something about the way we sense and are attracted to color, there is also a highly subjective side to the issue. We're not just drawn to color mechanically, but also by what it *means*.

ISO 100, 3.2 sec., f/14, 17mm lens

This chapter will highlight why paying attention to color helps you convey certain feelings or moods, as well as how individual colors are typically interpreted by viewers. In essence, this chapter is about several popular colors' personalities.

Before we dive into the specific colors, it is worth noting again that this is a move away from the scientific characteristics of color and light and into their observably subjective nuances. Nothing about the meaning of color is set in stone, and I don't necessarily encourage viewing the same color the same way every time you use it in studio work or come upon it on the street. However, the overarching meanings of a color come from its continued use in certain situations in a society and a culture. We understand that color as it is used and observed in those circumstances over long periods of time.

For those reasons, the colors identified next will be discussed in regard to their broad, socially and culturally conveyed meanings, and more specifically from a Western cultural perspective. As you read the following sections, you might also consider other popular meanings assigned to these dominant colors. To exhaust the personalities of different colors is impossible, but we can become very familiar with their typical meanings, which will guide our shooting choices to help us make visually powerful and meaning-filled photographs.

RED

I have talked a lot about red in this book thus far, and for good reason. Overall, red is a very aggressive color, both technically and in interpretation. Since it stands out so well among other colors, dominating them, it is seen as being demanding, in charge, and controlling. Red is loud (**FIGURE 5.1**)! This is easily noticeable when you walk into a room painted red. As much as this might pose a problem for color correction, a completely red room sets a certain mood, particularly if you are shooting portraits inside it. It might speak to the seriousness and aggressive energy of the person in the image.

FIGURE 5.1 Red boots can suggest aggressiveness and flamboyance. The person wearing them wants attention and means business—whether having fun or not (opposite page).

ISO 1600, 1/160 sec., f/2.8, 200mm lens

Power is another meaning conveyed by the color red (**FIGURE 5.2**). As mentioned, its boldness suggests dominance over other colors, and if used appropriately, it says the same of a subject in an image. For example, a red tie worn with a black suit and white shirt is a simple mark of authority in certain industry circles and sectors of business; it's even called a power tie. Commercial photographers are apt to introduce red into the image when a boost of strength is needed to send home a message.

Red is also commonly associated with speed and all that is fast. How many times have you heard that police officers are more likely to pull red cars over than cars of other colors (**FIGURE 5.3**)? Whether or not that's true, red has a racy connotation. Relative, again, to its technical characteristics, red gives life to inanimate objects such as vehicles, uniforms, instruments, and even toys.

The phrase "seeing red" alludes to someone who is angry. Anger is sometimes synonymous with being aggressive, and certain bold reds may also convey the same emotion, particularly if they're tied well with the subject of the shot.

As angry as bold reds can be, they may also convey love and beauty. Pink flowers may exhibit a soft prettiness, while a fiery red dress may express sensuality and passion and a snug pair of red pants may suggest sassiness (**FIGURE 5.4**). Red tends to be an extreme color, both technically and interpretively. There really is no in-between for red—it either provides a spark to other colors and subjective characteristics in the shot, or it is the entire fire!

FIGURE 5.2 The red of the school colors served as a nice backdrop for this portrait of a school superintendent, lending visual attraction and indicating his power.

ISO 200, 1/50 sec., f/2.5, 50mm lens

FIGURE 5.3 Classic car aficionados know the Chevelle as a speedy vehicle.
The red paint job says *fast* to everyone else!

ISO 100, 1/1600 sec., f/2, 50mm lens

FIGURE 5.4 Red is often used on women in fashion advertisements to spice up an image's attitude, as with the red pants in this western shot (opposite page).

ISO 400, 1/200 sec., f/4, 115mm lens

BLUE

Although not technically the opposite of red, blue is subjectively about as different as it can get. Whereas red is aggressive and energetically finicky, blue is characterized as a stable color with a great deal of integrity. Blue does not put us on high alert, but rather is something with which we're comfortable (**FIGURE 5.5**). Most of us are used to seeing blue as a constant in our lives—the sky is blue, and water— since it reflects the sky—is blue, and we see these elements on a regular basis. Blue, therefore, can simply seem reassuring and to some extent, conveys a sense of trustworthiness.

Blue is often associated with a winning quality in a person or thing (**FIGURE 5.6**). A blue ribbon represents first place, heroes (whether in myths or in contemporary fiction) are frequently clothed in blue, militaries have frequently been clothed similarly, and even religious figures are typically portrayed in or immersed in a blue of some sort. In this sense, blue connotes respect for those who are either adorned in it or appear with it as a significant color in the image. Large amounts of blue, whether on or near a human subject, might also convey a sense of unmoving stability (**FIGURE 5.7**).

FIGURE 5.5 The palette of blue in the design of this art museum is easy to look upon and puts the viewer at ease.

ISO 100, 1/80 sec., f/11, 52mm lens

FIGURE 5.6 Blue is a popular color for all or parts of uniforms, and it often is meant to represent a winning quality, such as the blue on this cyclist's tri-suit and helmet (above).

ISO 400, 1/1600 sec., f/5.6, 400mm lens

FIGURE 5.7 This large mountain cloaked in blue shadows gives a sense of endurance that stands the test of time (right).

ISO 100, 1/400 sec., f/4, 300mm lens

FIGURE 5.8 Surrounded by bright and aggressive colors that the kite maker uses in designing his wares, his baby blue shirt conveys a sense of calmness that even the eagle above must recognize!

ISO 400, 1/40 sec., f/5.6, 17mm lens

Technically, blue is very easy on the eyes, even bright, pale blues. Since it is not physically disruptive, one might say that blue conveys peacefulness (**FIGURE 5.8**). A baby blue is soothing in the right context, whereas a navy blue instills a sense of security. Again, this harks back to blue's ability to instill trust and confidence. If there was a color that you could "set your clock to" in regard to its consistent, comfortable nature, blue would be it.

Some more calming blues, however, may also convey a sense of weakness. Now, I know what you are thinking. How can the world's most popular color (as some marketing studies have shown over time) be seen as, well, wimpy? How can this color be construed so negatively? Just as red is aggressive, blue can be perceived as not only stable but sometimes reticent. Different hues of blue, just like any color, say different things to different people. Blue has also been attached to depression and sadness (**FIGURE 5.9**). Why do you think they call a certain genre of music the blues?

FIGURE 5.9 Shrouded in a blue fog, downtown Austin, Texas, does not excite viewers like its vibrant cultural activity does on its streets.

ISO 200, 1/80 sec., f/5.6, 200mm lens

FIGURE 5.10 A brisk touch of electric blue on the camera–right side of this skull lends a boost to its spooky nature.

ISO 400, 1/160 sec., f/18, 200mm lens

Finally, it is not so uncommon—especially in contemporary imagery—that blue suggests an icy, not-so-nice personality. Dependent upon subject matter contained within images, blue can be just as cold and evil (**FIGURE 5.10**), or melancholy, as it can be sweet and calming. Pay attention to how post-processing high-contrast images to a more blue tone gives them a sense of mystery and darkness.

GREEN

All of the colors discussed in this chapter have varied meanings, but when you reflect on your own interpretations of them, most colors have a dominant perceptual characteristic. Green, however, is one of those colors that combines contradictory positive and negative nuances.

Green is the color of growth and life (**FIGURE 5.11**). We compare green to grass. We call someone who is just a beginner "green." Green provides a sense of the future. Growth occurs over time, and people tend to think of growth as a positive, hopeful progression. Green is also a color associated with caring (**FIGURE 5.12**). Probably the biggest proponents of the color green, conservation organizations heavily exploit the color green, mostly because of what they are trying to conserve. The more we see green associated with their efforts, the more we read similar meaning into it in other areas of society and culture.

Of course, I would be remiss to not mention green as directly tied to nature. Our feelings associated with being outdoors can be visually expressed mostly using shades of green. The spring season is often represented by greens sprouting from barren earth tones (**FIGURE 5.13**). Green is also exotic. It is associated

FIGURE 5.11 Healthy green leaves on a pecan tree in the Texas Hill Country (opposite page).

ISO 200, 1/210 sec., f/2.4, 60mm lens

FIGURE 5.12 A greenhouse gardener shot for the cover of a local magazine. A palette of greens was essential to depict this person as a caretaker of all of the growth present.

ISO 100, 1/160 sec., f/4, 60mm lens

FIGURE 5.13 John Deere had it right when it picked green as its official color. The color speaks to the synergy between land and what springs from it.

ISO 400, 1/50 sec., f/11, 99mm lens

with uncommonly seen jewels, such as jade and emeralds, and might add just the right touch of mystery to any scheme or visual palette (**FIGURE 5.14**).

Inversely, though, green is also associated with feelings of jealousy and toxicity (**FIGURE 5.15**). The phrase "green with envy," whether or not inspired by the color green, signals a negative association with the color. Also, consider what color filmmakers typically choose for poisonous slime or vials of disease—a fair share of them are green. Certain greens inspire feelings of illness, and in some settings where old fluorescent lighting is allowed to appear in images, we can see why.

FIGURE 5.14 The Greenwood Grocery, an aptly named local gathering spot, stays hidden among a thick wooded area and is considered a precious gem by its customers.

ISO 200, 1/40 sec., f/8, 24mm lens

FIGURE 5.15 Landscape shooters recognize and stay clear of that special hue of green seen in the bottom left clump of vegetation: poison ivy.

ISO 100, 1 sec., f/22, 17mm lens

YELLOW

FIGURE 5.16 Yellow sings in great light, expressing a lot of energy.

ISO 100, 1/3200 sec., f/2.8, 24mm lens

Yellow is simple. It is energetic. In fact, it might be the most positively energetic color out there (**FIGURE 5.16**). Yellow is typically associated with unbridled happiness and fun. A popular summer color is yellow, and summer is equated to joy and a break from the mundane and routine (**FIGURE 5.17**). It makes sense that yellow would take on those same characteristics of fun and relaxation.

Yellow is also symbolic of peace. In certain societies, yellow conveys a sense of reason and deliberation that maintains such peace. Lighter yellows are calming (**FIGURE 5.18**), and when combined with even lighter colors or tones, such as white, yellow accents the purity of the subject matter adorned in its color. When yellow is more golden, it quickly becomes symbolic of luxury and nobility (**FIGURE 5.19**).

FIGURE 5.17 Flying a kite is a great summertime activity, and a yellow kite is the perfect flying machine to have along.

ISO 100, 1/125 sec., f/11, 17mm lens

FIGURE 5.18 A field blanketed in yellow coreopsis is both exciting and calming at the same time, especially when bathed in great natural evening light.

ISO 100, 1/40 sec., f/8, 17mm lens

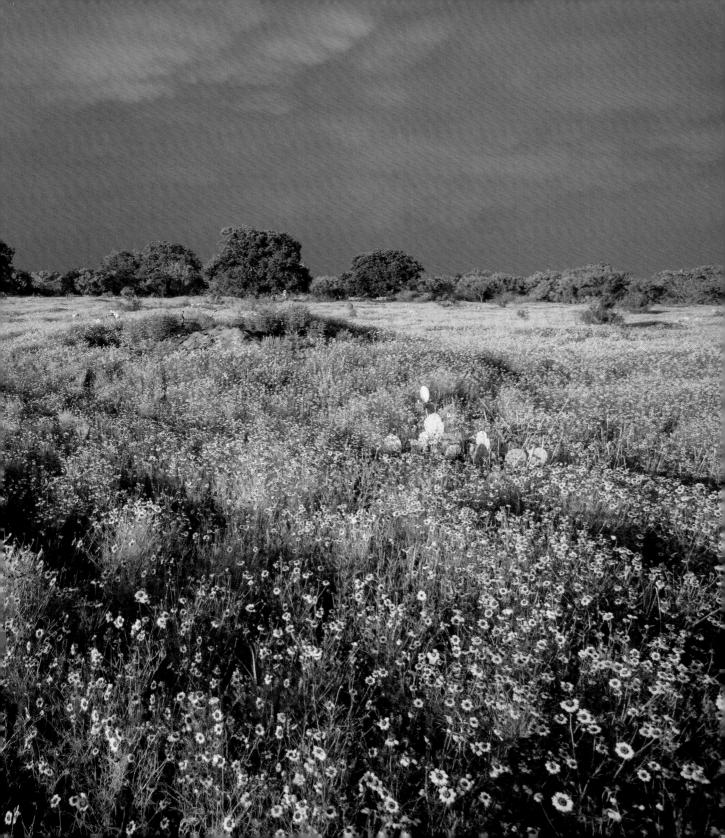

On the other hand, it is common to refer to an individual acting cowardly as yellow (more so in the previous century). To that end, yellow can be negatively associated with fear and even betrayal.

Yellow can also create feelings of anxiety in its viewers, particularly if used in large amounts. Imagine walking into a room with no windows and walls painted a bold, bright yellow. It can actually be a rather unnerving color when seen taking up so much visual real estate. Understanding this serves us well when we wish to either convey or avoid this feeling when shooting.

FIGURE 5.19 The yellow–gold accent lights lining the upper walls of this Santa Fe restaurant and music venue add a certain richness that is lacking in just the red stage lights alone.

ISO 100, 1/60 sec., f/2.8, 24mm lens

ORANGE

Another color that expresses a great deal of energy, orange, also is one that for the most part resounds positively with many subjects and image viewers. Since it technically is close to red on the visual spectrum, it can serve to represent danger, but beyond the occasional warning sign, it's a particularly cheerful color (**FIGURE 5.20**). As with yellow, it occurs naturally in the warmer seasons (think of yellow sunflowers and orange poppies, or leaves changing to shades of yellow and orange), so it is common to see the color orange used to represent warmer seasons and playful summer moods.

Orange is extremely active (**FIGURE 5.21**). It can be used to represent labor and athleticism, as well as mental activity. It is rather stimulating and intriguing (**FIGURE 5.22**); it rests between an in-your-face red and a more subtle yellow. It is the eccentric cousin to both, and it can't quite be pinned down. It is powerful and joyful at the same time (**FIGURE 5.23**). It is a hard-hitting color just as much as it is an easygoing, summer-fruit boost of emotional vitamin C.

Orange is also rather earthy. The browns of dirt and the terra cotta of building architecture introduce varying levels of orange (**FIGURE 5.24**). Pumpkins and squashes lying on the ground suggest harvest. Using orange, particularly in conjunction with complementary colors, is a natural choice when you want to suggest earthiness, connection to the land, and bounty.

FIGURE 5.20 Like red vehicles, orange ones easily stand out, but orange has a certain happy energy to it versus an "I'm faster than you" attitude (opposite page).

ISO 50, 1/3200 sec., f/2, 50mm lens

FIGURE 5.21 As the complement of blue, orange has been adopted by many trades necessitating heavy safety awareness, such as construction.

ISO 100, 1/125 sec., f/8, 24mm lens

FIGURE 5.22 The orange glow from the interior of the art gallery is inviting, begging a closer inspection.

ISO 800, 1/60 sec., f/4, 24mm lens

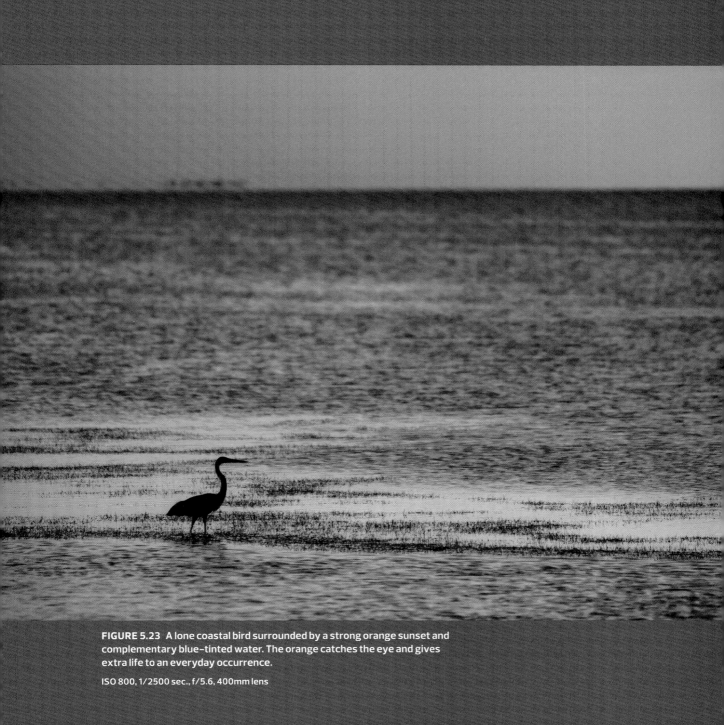

FIGURE 5.23 A lone coastal bird surrounded by a strong orange sunset and complementary blue–tinted water. The orange catches the eye and gives extra life to an everyday occurrence.

ISO 800, 1/2500 sec., f/5.6, 400mm lens

FIGURE 5.24 The orange clay–sand washing off the tires is a welcome sign for many cotton farmers come summertime (opposite page)!

ISO 200, 1/125 sec., f/4, 300mm lens

PURPLE

Purple has always eluded my liking until recently. If green is my favorite color, and yellow my not-so-favorite, purple, or violet, might be the color I've thought of the least. It just so happens, though, that it is my wife's favorite color, and I've grown to appreciate it used in special environments. Perhaps when compared with other colors discussed here, purple simply doesn't show up as much in everyday life for the majority of us. The infrequency of its use, however, does not take away from its interpretive value.

Arguably, purple harbors the deepest meaning of all the colors. To start, purple is magical and associated with otherworldly things. In visual storytelling, especially fictional staging, purple helps establish an environment in which we mortals simply do not belong. I'm often reminded of this when I watch and photograph thunderstorms; the lightning bolts tint the sky a pale purple, as though the gods of the sky are stirring (**FIGURE 5.25**).

FIGURE 5.25 The lightning bolt accompanied by the purple sky suggests larger forces at work above, providing an otherwise mundane ranch scene a mystical quality (next page).

ISO 100, 3.2 sec., f/16, 24mm lens

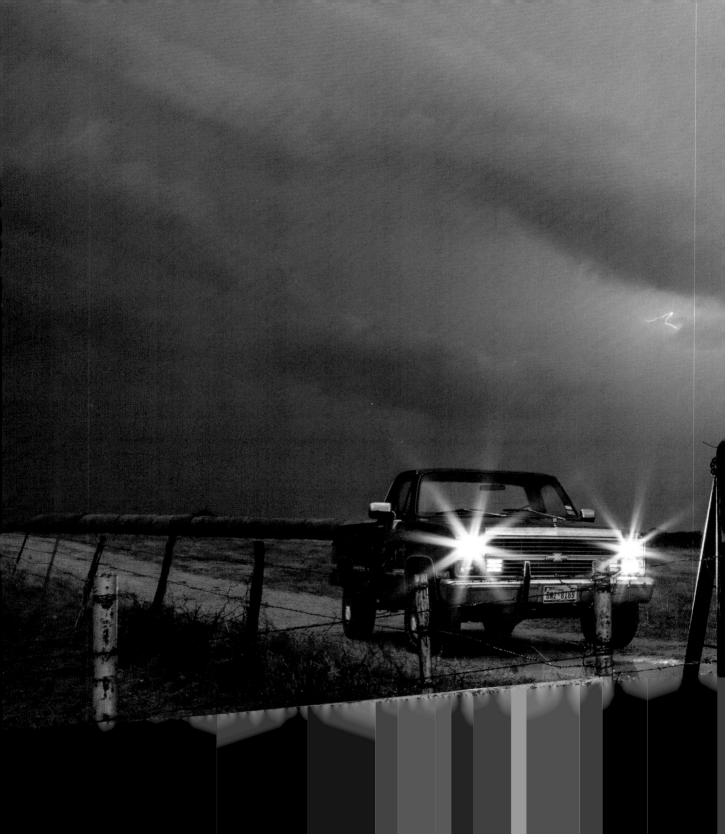

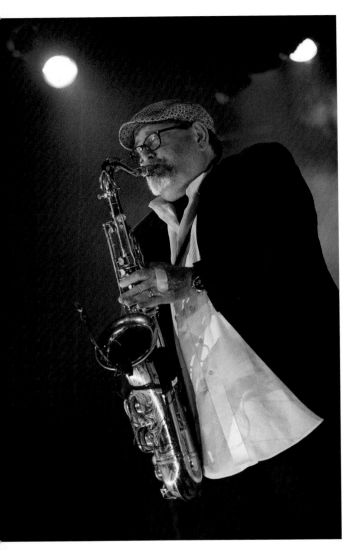

FIGURE 5.26 The purple stage light framing legendary producer Don Caldwell makes him the king of the saxophone for the time being.

ISO 1600, 1/320 sec., f/2.8, 80mm lens

I suppose that it is this exclusiveness that also ties the color to royalty and exclusivity (**FIGURE 5.26**). Purple, particularly darker violets, traditionally conveys a sense of authority and a necessity for respect. We sometimes see religious figures and nobility dressed in purple or given a background of that color in images (**FIGURE 5.27**). It signifies the subject's value and royal appeal for believers and followers.

At the same time that purple commands authority and exhibits royal elegance, it is also mysterious. It expresses a darker personality, one we cannot read completely. The color purple can be used to lead a viewer but perhaps not reveal all.

Lastly, purple is often associated with death. In certain cultures, purple is a common color to be worn while mourning the loss of a loved one. Color researcher and consultant Patti Bellantoni is so sure of purple's association with death that she even named a book on the subject of color in cinema titled "If It's Purple, Someone's Gonna Die," referring to how purple is present in many parts of a movie that contain death.

Like other colors, a lighter shade of purple might not convey the same personality that "death purple" does, but within each color is a subjective flexibility that allows our readings of that color to adjust based on situation, image content, and the evolving meaning of color in general.

FIGURE 5.27 As a figure of royalty for Christianity, Jesus Christ is appropriately depicted on a background of a variation on purple in this painting on the streets of Seville, Spain.

ISO 200, 1/160 sec., f/4, 92mm lens

FIGURE 5.28 Worn white crosses convey a sense of peace for those buried in this Chihuahuan desert near the Texas–Mexico border.

ISO 100, 1/100 sec., f/16, 17mm lens

WHITE

Not so much a color as it is all colors combined, white still holds profound and yet simple meaning for society, particularly the Western world. To be truthful, white possesses enough meanings to fill volumes, but suffice it to say that its characteristics are generally positive.

White is typically tied to peace (**FIGURE 5.28**). Even though a white flag signals someone's or some entity's surrender, it is supposed to bring an end to the ongoing conflict. White also conveys virtue and purity (**FIGURE 5.29**). One of the reasons we like to use high-key contrast lighting for children—lighting that forces tones in an image to brighten so much that they are nearly overexposed—is to showcase their innocence and ability to approach the world with a clear slate. Wedding dresses are often white for similar reasons. White, like several colors discussed here, has its own elegance, but it might require a different interpretation than the others.

FIGURE 5.29 The white blossoms of the apple trees that Eva is investigating also highlight her innocence as a toddler.

ISO 50, 1/1000 sec., f/2.8, 200mm lens

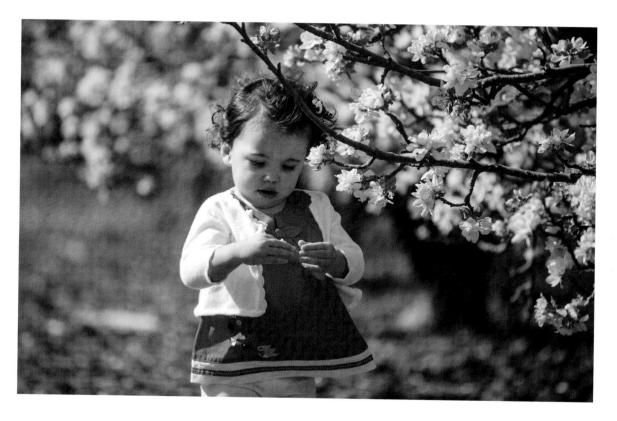

FIGURE 5.30 A white tablecloth is an elegant, unobtrusive, and clean foundation on which a chef places her masterpieces, much like the background a portrait photographer may choose for his subjects.

ISO 400, 1/50 sec., f/2, 50mm lens

White can also serve as a rather benign, unobtrusive tone on which to place subject matter of importance (**FIGURE 5.30**). Richard Avedon, the champion of the plain white background, intentionally used the stark neutrality of it to isolate his portrait sitters and to force the viewer to study only them and not his technique.

BLACK

No other color (or lack of it, to be accurate) has been used more to describe negative emotions and ambience (**FIGURE 5.31**). Black is often used to visually describe evil and highlight subjects as sinister. The black cowboy hat adorns the antagonist in many traditional westerns, the classic film noir look is based heavily on the distinct contrast between black shadows and highlights created by direct lighting, black is used to surround evil mythical creatures, and we are all just a little afraid of the dark. In this sense, black runs the gamut from seat-of-the-pants edgy to full-blown gothic-era-inspired scary!

Black can often represent opposition (**FIGURE 5.32**). Whether that opposition is focused on "the man" or social injustice, black has traditionally played a visual role in contextualizing such sentiment in arenas of popular culture, such as music and dance.

FIGURE 5.31 If you want to make someone look intimidating, put him in a black shirt and a dark environment, shoot from below, and light from high above.

ISO 200, 1/30 sec., f/8, 17mm lens

FIGURE 5.32 The simple integration of black sunglasses with an ambivalent expression conveys an edgy attitude.

ISO 100, 1/200 sec., f/16, 55mm lens

Like purple, black is also used to visually symbolize death and mourning. It is also used to indicate formality (the dress suit, a black dress, a limousine) and sleekness. There is a richness to black that isn't necessarily technically translated from a scientific perspective. Instead, it is a cultural sign of exclusivity (**FIGURE 5.33**), such as that which surrounds black-tie events or black cocktail dresses.

THE INTERPRETIVE WRAP-UP

The preceding sections highlight in a basic fashion the way we often describe color, perceive it, and are emotionally moved by it. The statements might sound like bold claims, but they are, after all, how many societies perceive many of the colors discussed. These are typical emotional and characteristic designations that we can effectively use as photographers to make our images more powerful.

Should you totally rely on just these designations? Will you always be able to use colors to evoke the emotions and feelings listed above? No. This is the stickiness and beauty of subjectivity. At any given time, the meaning of a color may change, particularly when it is combined with the subject we are photographing. We're not always going to be able to come upon these colors "in the wild" at the right time for them to evoke these feelings, either. But when we're presented with the opportunity, widely held understanding of what colors symbolize can come in handy. These understandings are conditionings we get from exposure not just to nature but to a wide variety of media, people, stories, and so on. In great part, our understanding of color is a result of being reared in a particular culture, which will be discussed in the next chapter.

FIGURE 5.33 A deep black background and shadows in this portrait create not only visual contrast but an isolation that sets this singer apart from the rest.

ISO 200, 1/30 sec., f/8, 105mm lens

Culture and Color

What do you think about when someone mentions the country India? Mexico? The city of Santa Fe? What about your own city or town? Among many other things, you think, consciously or unconsciously, about the color that typically represents those places. I've never been to India, but based on my colleagues' work, I understand that color appears differently there than in the United States.

Whether or not you've spent any time studying it, color is important to every culture and subculture in the world. So, not only is color a subjective, highly personal facet of life, it is also defined differently by cultures around the world. This chapter will explore where unique color in cultures can be found, as well as highlight the value of recognizing how color is perceived by people in various cultures.

ISO 100, 1/200 sec., f/8, 70mm lens

FINDING CULTURAL COLOR

One of the things that excites me about traveling is being in an environment that *looks* different. Granted, when we boil it down, we see the basic necessities of human life just about anywhere. But, each society, each culture has a unique way of presenting its vision of life. Regardless of where you are, or who you are interacting with, there are a few places to always look for culture's colorful side!

Food

Let's start with food (and drink). Who wouldn't? Food has long been a vital facet of culture. It's one of the reasons for traveling or enjoying being in a different culture. The way it is prepared and presented is a very visual way of telling the consumer what type of food it is. Mediterranean tapas are one of the most visually attractive and colorfully appealing foods out there (**FIGURE 6.1**). Did I mention they are some of my favorites as well? Not only is the food itself colorful, but given the right chef, the dressing of the food and the plating can be as well (**FIGURE 6.2**).

Not only is the food itself important from a color point of view, so are the colors of the place in which it is served (**FIGURES 6.3** and **6.4**). As photographers, we're trained to be extremely aware of our surroundings, and restaurants, cafés, coffee shops, and the like are some of the most colorful spaces in a given culture (**FIGURE 6.5**), especially the interiors. Even farmers' markets in different countries have their own colorful appeal; some produce is consumed more heavily in certain cultures than in others, and available foods might even indicate a particular geographical region of the world (**FIGURES 6.6** and **6.7**).

FIGURE 6.1 A bright Mediterranean dish at a home in southern Seville, Spain (opposite page).

ISO 400, 1/125 sec., f/2, 50mm lens

FIGURE 6.2 A similar offering presented in an American tapas restaurant, dressed by a chef inspired by the culture in which I first encountered it (left).

ISO 250, 1/60 sec., f/2.8, 70mm lens

FIGURE 6.3 A chilled, refreshing margarita. The popular Mexican cocktail exhibits the same joyful coloration that manifests itself in much of the nation's architecture, decor, and clothing.

ISO 200, 1/125 sec., f/2.8, 155mm lens

FIGURE 6.4 A portrait made in the same cantina in which the margarita is sold. The background colors alone give clues about the culture being photographed. (left)

ISO 1600, 1/60 sec., f/2.8, 40mm lens

FIGURE 6.5 Colorful places invite colorful people, making cultural photography that much more interesting and exciting (below).

ISO 1000, 1/80 sec., f/4, 17mm lens

FIGURE 6.6 Vivid, red strawberries, predominantly a temperate-climate fruit, at a market in Amsterdam, the Netherlands.

ISO 100, 1/250 sec., f/2, 50mm lens

FIGURE 6.7 Fresh okra is a southern United States staple (opposite page).

ISO 200, 1/80 sec., f/8, 55mm lens

Housing

Residential areas are also colorful ambassadors of culture. No matter where you are in the world, housing's color conveys something about the culture. Even the suburbs, which tend to have a certain uniformity about them in some societies, speak with color. From the exterior walls of a house or flat (**FIGURE 6.8**) to the flowers the owners plant in their front yards (**FIGURE 6.9**) to the color of their living rooms (**FIGURE 6.10**), people express themselves in their personal environment. And often the colors used are something of an indicator of that person's larger culture.

Spain is one of the most colorful places I have ever visited. It boldly incorporates many bright and reaching colors, both in its Mediterranean landscape and in its urban areas (**FIGURES 6.11** and **6.12**). As a result, we get a feel for the vibrant nature of its people, whose colors of choice may be influenced by the natural coloration of the scenery. Other cultures heavily use colors that immediately surround them, as well. New Mexico, and much of West Texas, is surrounded by arid land that transitions to desert in large areas. Santa Fe, and many cities in New Mexico, embrace this coloration in adobe-walled buildings and bright blue trim representative of the large sky above the land (**FIGURE 6.13**).

FIGURE 6.8 A colorful Spanish roofline under a visually enticing cloud structure.

ISO 100, 1/30 sec., f/8, 24mm lens

FIGURE 6.9 A white-walled home in Cordoba, Spain, is kissed with color by the owner's fun mixture of purple and pink petunias.

ISO 100, 1/80 sec., f/5.6, 58mm lens

As photographers, we like to shoot colorful exteriors because when great light hits them, the colors pop even more! Look around you and get a feel for the color that is part of large structures. Imagine how that color is best exploited by light. Ask yourself if it is part of a cultural story, and then look for any way to combine that color with other cultural content to bring home the idea that it is all tied together.

FIGURE 6.10 White or lighter–toned kitchens, popular in the United States, not only reflect great window light, they also convey a sense of freshness and cleanliness.

ISO 200, 1/100 sec., f/3.2, 17mm lens

FIGURE 6.11 A pleasantly yellow-walled residential structure in Madrid, Spain.

ISO 400, 1/320 sec., f/4, 50mm lens

FIGURE 6.13 Two of the most popular colors used in Santa Fe–style architecture are those that resemble the ground on which the buildings are constructed and the bright blue of the sky above.

ISO 100, 1/200 sec., f/8, 70mm lens

FIGURE 6.12 The striking and energetic colors of Plaza Mayor in Madrid, Spain, are immediately attractive to photographers and let visitors know they're in a creative culture (left).

ISO 100, 1/1600 sec., f/2, 50mm lens

Traditional Clothing

Clothing seems like a fairly obvious cultural indicator, and so it should be. It is one of the first facets of culture we notice, and people tend to want to fit in with their peers to some extent. Like the color of architectural structures in a given society, the color of clothing can help reveal where an individual is from or what culture he identifies with, particularly if it is a rather specific or showy type of clothing. One type that screams culture is the traditional garb of the particular area.

Take, for example, cowboy clothing. The American cowboy's wardrobe really hasn't changed much in the past century or so (**FIGURE 6.14**). It has retained the ruggedness required by the job, and the colors—light and earth-toned in order to thwart the unbearable burn of the summer sun—have adjusted to contemporary style ever so slightly (**FIGURE 6.15**). Traditional styles and coloring of cowboy clothing have been an icon of the American West for quite some time—and you're not likely to see too many cowboys wearing violet or chartreuse work shirts any time soon, although you might see some men sporting those colors for work in the city.

FIGURE 6.14 Brown leather chaps, a light tan long-sleeved work shirt, and a similarly colored felt hat seem fitting for ranch manager Mark Kirkpatrick and the thousands of cowboys out there who wear similar-colored clothing to fend off rough brush and open sunlight when in the saddle (opposite page).

ISO 200, 1/5000 sec., f/2.8, 105mm lens

FIGURE 6.15 The summer plaid of more contemporary, cowboy-influenced styling still fits in well in any western town.

ISO 50, 1/200 sec., f/5.6, 110mm lens

FIGURE 6.16 Modern-day Euro-American mixed styling and color suggest a more global influence on fashion.

ISO 100, 1/400 sec., f/2.8, 165mm lens

Contemporary clothing gives us insights into modern-day culture (**FIGURE 6.16**), but traditional clothing is what we more than likely become familiar with when learning about other cultures. Before my first trip to Spain, I had a good idea of the personality of the country on a broad level given my research and people I knew from the country—and one thing that stood out was the presence of strong, physically reaching and bright colors in traditional formal wear (**FIGURE 6.17**). Of course, that color finds itself permeating the country's architecture and art as well, especially in the urban environments. I was expecting to see incredible coloration while out and about in places like Madrid and Seville, and I wasn't let down. In regard to color alone, the cultural environment differed from that of the United States, and it was imperative to incorporate it into the images I was making along the way.

Of course, any culture has many more dimensions than just its color, but color is certainly key. As we have seen, it appears in every facet of culture, from food to architecture, and it doesn't have to always be bright oranges and indigo blues or something eye-catching. No matter how bold or submissive colors may be, it is equally important to consider how the people who live among certain colors perceive them.

FIGURE 6.17 Holiday street festivities in Madrid, Spain, are supported by the eye–catching colors of traditional formal dress wear.

ISO 200, 1/800 sec., f/2, 50mm lens

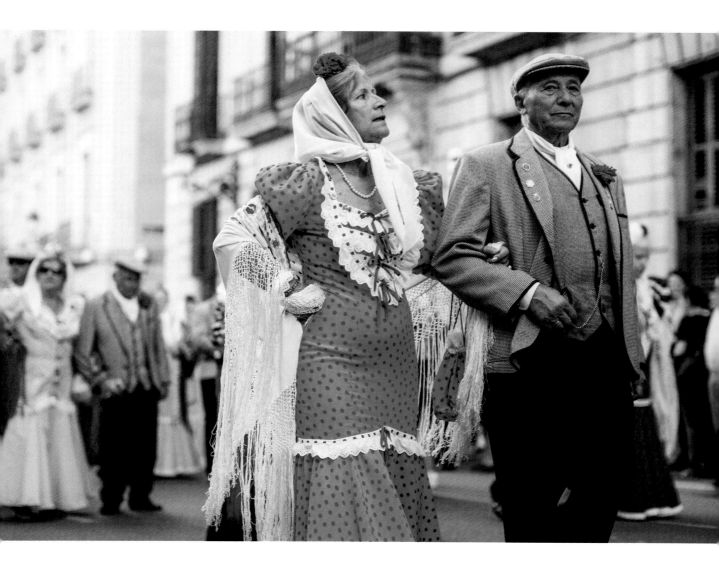

CULTURAL PERCEPTION OF COLOR

Color can also be made more interesting and meaningful in photographs by having a working knowledge of what specific colors actually represent to a given culture. Take national flags, for example. Citizens of a nation regard their flag a particular way, and many have a strong idea of what the colors in the flag mean (**FIGURE 6.18**). Semiotically, those colors—especially when combined—symbolize the unifying characteristics among the individuals in a population, as well as other qualities that make up the personality of a nation. When an American sees red, white, and blue together, even if they're not in a flag, the color combination typically connotes pride, honor, strength, and unity. For our neighbors to the south living in Mexico, the green in their flag connotes hope, the white peace and harmony, and the red the sacrifice made in order to establish the country. Those colors can evoke emotions just by themselves. It's little wonder flags are prominently displayed and cared for.

Chapter 5 highlighted the broad meanings and symbolism of several popular colors from a fairly Western cultural perspective. However, the emotional appeals outlined may not hold true for other cultures. Whereas red may suggest aggressiveness or anger in Western culture, it is often associated with happiness in Eastern cultures. Pointing out all of the differences between cultures around the world would indeed fill volumes, although one would notice a few strong similarities as well. Suffice it to say that doing a bit of research on any culture you expect to encounter photographically can go a long way, and colors that are especially meaningful to that culture should not be passed over.

FIGURE 6.18 Big or small, the flag of the United States of America holds strong interpretive value when it comes to its colors. The same can be said for any nation's banner (opposite page).

ISO 800, 1/640 sec., f/2, 50mm lens

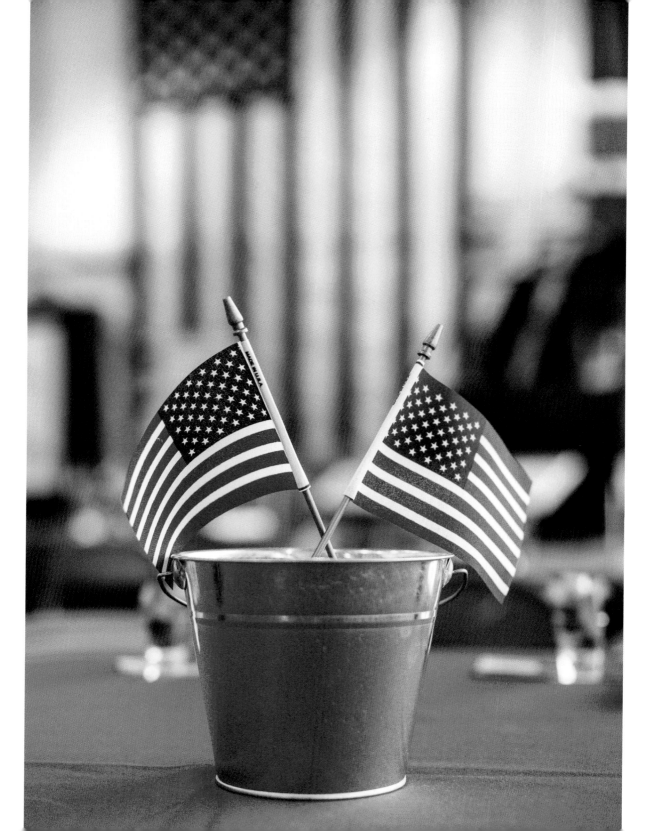

Subculture and Color

Color is also an important symbol for smaller subsets of the same culture. Subcultures may be as large as entire religions or as small as a small-town high school or prominent community service group, and each may hold certain colors as valuable and representative over others. Green, for example, is the color that represents 4-H clubs and agriculture all across the world (**FIGURE 6.19**), but it is also a color that's very meaningful to Islam. On the same note, a rainbow is often symbolic for Christians (**FIGURE 6.20**), but it also serves as a universal symbol for the lesbian-gay-bisexual-transgender community. Gangs in big cities have adopted their own colors and are hyper-aware of the colors of competing gangs—it can even be dangerous to wear a particular color in such a context.

Music fan culture has always incorporated color into its identification. Black, for instance, has constantly been a part of rock music since the late 1960s (**FIGURE 6.21**). It has manifested itself in several variations—from the black sunglasses worn by many a famous rocker to the all-black wardrobe of metalheads and the like. The hippie era is often visually represented by colorful tie-dye, and the hair metal scene in the 1980s was overrun by bright, almost-neon colored leotards and, you got it, hair! As instruments of popular culture, music subcultures are constantly embracing colors that represent different meanings, which largely coincide with interpretations mentioned in the previous chapter.

FIGURE 6.19 Late July sorghum fields in Acuff, Texas. It's little wonder agricultural organizations and businesses the world over adopt green as their signature color (opposite page, top).

ISO 200, 1/60 sec., f/11, 17mm lens

FIGURE 6.20 Given the right subcultural context, the colors of a rainbow can be interpreted a few different ways, each holding particular meaning for certain cultures (opposite page, bottom).

ISO 100, 1/160 sec., f/11, 20mm lens

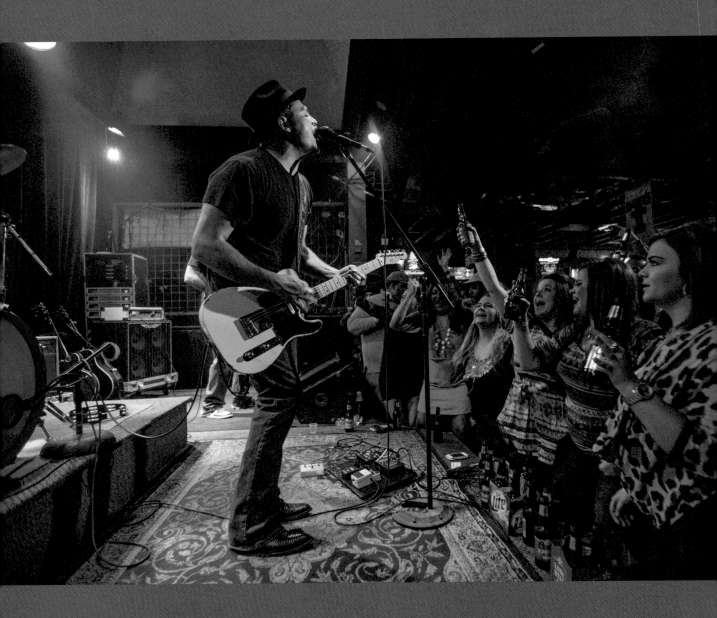

FIGURE 6.21 Put a black shirt on someone, throw an electric guitar in his hands, add some contrasty stage lighting, and you have a great visual mixture that screams rock 'n' roll (opposite page).

ISO 2000, 1/125 sec., f/2.8, 17mm lens

Probably some of the most popular subcultures in general Western culture are those revolving around sports organizations, whether they're professional teams or those tied to an educational institution. The fans and marketers of such entities find incredible value in the colors that identify the teams. I teach photography at a university where the official colors are simply red and black (**FIGURE 6.22**). Needless to say, on any given day, I see thousands of red, black, or red and black T-shirts, caps, coats, and even shoes on campus (**FIGURE 6.23**). The university's rallying fight song even references the school colors, further promoting sentiment toward them. I dare say that anyone who ever went to school at or is a fan of Texas Tech University is emotionally affected by that combination of colors, as I expect anyone who attended a particular university would be by their school colors.

As visual storytellers, some photographers may visually depict a variety of subcultures throughout our tenure—professional or not—with the camera (**FIGURES 6.24** through **6.27**). One of the greatest things about doing so is the ability to get to know a lot of individuals and locations in a variety of cultural contexts. Along the way, we pick up on the nuances of the people and places that pique our interests. Color is a notable component of our immersed experience, particularly if we choose to highlight it as an important part of the story being told.

Additionally, paying attention to trends that occur in society also gives the aware photographer insight into cultural color. This does not mean it's a requirement for you to be trendy yourself—something of which I've never been accused. However, it does mean staying somewhat knowledgeable about what is happening on a number of popular cultural fronts, including music and clothing, as discussed above. Don't worry about becoming a fashionista or pop culture savant. Simply look around you and pick up on change as it happens.

FIGURE 6.22 Texas Tech cheerleaders clothed in the school's official red, while the entire audience surrounding them in the stadium wears the same.

ISO 200, 1/1250 sec., f/2.8, 400mm lens

FIGURE 6.23 A "blacked–out" Texas Tech student body cheers on its football team.

ISO 400, 1/640 sec., f/2.8, 400mm lens

FIGURE 6.24 Ever since Tiger Woods came up as one of the best golfers in the world, wearing a red polo shirt on the golf course tied you directly to the course and the sport—even for a seven-year-old getting out of the sand trap (above).

ISO 100, 1/2500 sec., f/2.8, 190mm lens

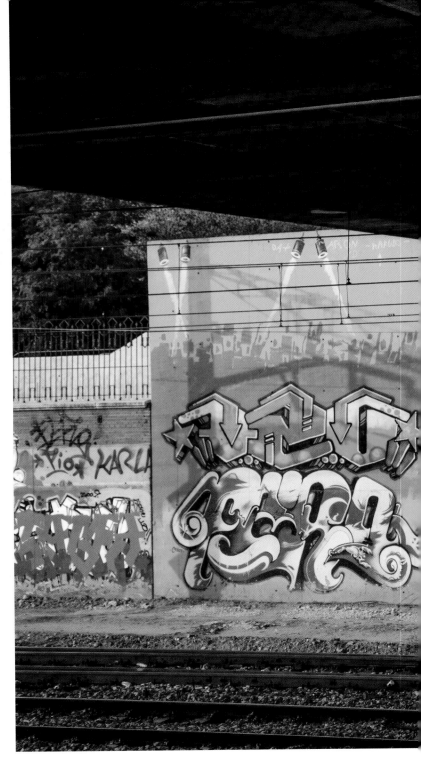

FIGURE 6.25 Graffiti artists are a culture unto their own, bringing plain walls and other structures to colorful life—sometimes at the risk of breaking the law (right).

ISO 200, 1/200 sec., f/8, 55mm lens

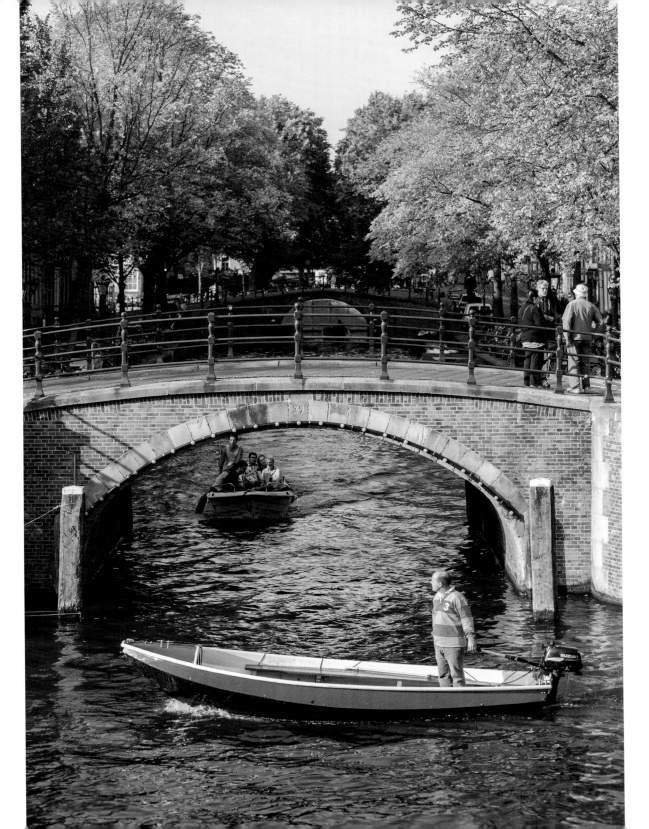

THINK LOCAL

One thing I'm prone to not consider when thinking about cultural photography is that culture that immediately surrounds me, in my own backyard, so to say. And yet, I'm constantly reminded that I'm an expert on my own local culture, especially when I visit with those who are not a part of it. I would assume that's the same for all of us. We know the ins and outs of our area, what makes it unique in the world, and even how others perceive it. We're familiar with the corner pub and the best hole-in-the-wall restaurants, and if we aren't, we're getting to that point as we constantly explore.

With that being said, take advantage of all that has been discussed thus far in capturing your local culture. What are its identifying colors? Consider all of the cultural components: the land, the people, the music, the art, the design, the architecture, the history, the religious leanings, the political leanings, and any other facets of culture you can explore visually.

FIGURE 6.26 Among the channels of Amsterdam, the Netherlands, one will notice many similar boats. Every so often a relatively more "loud" boat will pass by, indicative of many recreational boat users in the area (opposite page).

ISO 200, 1/1000 sec., f/2.8, 70mm lens

FIGURE 6.27 My good friend and duathlon athlete Patrick Merle colorfully exhibits his love for the sport and the culture that surrounds it in a few graduation photographs I made for him (above).

ISO 100, 1/1000 sec., f/5.6, 24mm lens

FIGURE 6.28 The region's "cultural" area, known as the Depot District, offers visual interest built around color and activity. In general, the color found within many venues is in stark contrast from that which exists outside.

ISO 800, 1/60 sec., f/3.2, 50mm lens

FIGURE 6.29 The Lubbock sky is often bald and blue, but it is iconic for producing extremely powerful visuals when a thunderstorm rolls through (opposite page, top).

ISO 50, 5 sec., f/6.3, 28mm lens

FIGURE 6.30 Two colorful icons of my region: Texas Tech's bell towers framing the school's mascot, Midnight Matador (opposite page, bottom).

ISO 100, 1/400 sec., f/4, 40mm lens

Look at your culture from an outsider's perspective. What would you want to know about it? How does color help communicate that knowledge? I live in a rather unique place in Texas. Lubbock is often defined by the large sky, a hard work ethic, isolation (it's a good five-hour drive across ranch country or the desert to a city of more than 250,000 people), and the hometown of Buddy Holly—or as I like to see it, the birthplace of rock 'n' roll as we know it. The "Hub City" resides on the eastern edge of what is called the Llano Estacado, or the staked plain, and at first glance, much of the color in the area resides in the land and sky (there's very little groundwater here) as opposed to the urban area.

However, color does indeed exist here, and it helps to define some of those characteristics I used above to describe my home (**FIGURES 6.28** through **6.31**). It's also a city in which a little digging will reveal a viable art and entertainment scene, and it's a crucial part of the music world, given its heritage and ability to produce great local talent that moves outward. Earth tones make up quite a bit of the color that defines the people and places of the city. Given the personality of

the place, it's not hard to see the agricultural industry's impact on the color across town. And with over 280 days of sunshine annually, it seems fitting that colors on the ground, in the fields, and sometimes the tones that make up xeriscaped lawns play well with the expanse of blue above.

So, what about your own local culture? Describe your city or town and what makes it stand out. See if there is a colorful characteristic about it and the people, and don't hesitate to make some photographs detailing that facet. If you don't know much about your local culture, use your camera as a gateway into learning more.

Unlike the sometimes nebulous interpretive characterization of color highlighted in the previous chapter, the significance of color in culture has the potential to be more grounded and specific. Red, white, and blue—especially said or seen in that order—will always resonate for Americans, whereas substituting green for the blue and orange for the red will hold more significance for the Irish. Far beyond the national colors of the respective countries, various colors help define a variety of other cultures and subcultures. As photographers, we have a great way to delve into the significance of color in culture and communicate what we learn visually to a broader community.

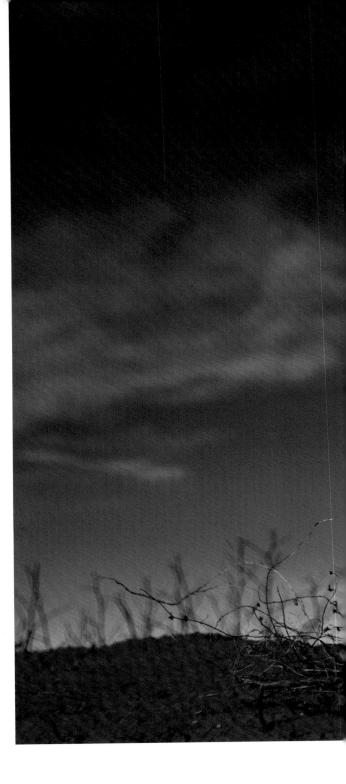

FIGURE 6.31 Cotton, the region's largest economic industry, is lit underneath a West Texas night blue sky.

ISO 200, 15 sec., f/3.2, 30mm lens

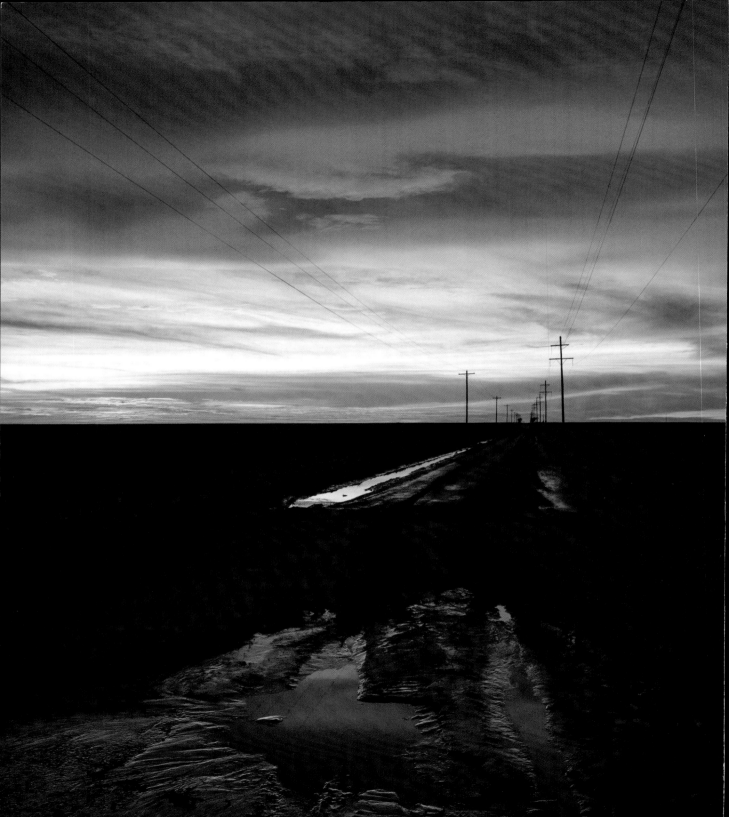

Conditions for Color

There's a time and a place when color really sings. Whether you're shooting landscapes, portraits, sports, or wildlife, at certain times of day color is dramatic and appealing—and that's when you can exploit color to the fullest extent. Environmental conditions and characteristics also help in capturing the best color for a variety of subject matter. Of course, these conditions depend on a key ingredient: light. This chapter discusses different conditions that are valuable for extracting color, and it emphasizes taking advantage of them in a variety of photographic situations.

ISO 250, 1/30 sec., f/5.6, 26mm lens

THE GOLDEN HOUR

Simply put, magic happens at the golden hour. For several reasons, the golden hour—the hour of light that occurs right after sunrise and again before the sun sets for the day—is thought to produce the best light for photography. Although some might argue that other good light does exist, the golden hour certainly provides excellent light for dramatic and bold color.

So, what makes the golden hour magical? Mostly the extreme angle of the light. At these times of the day, the sun sits low to the horizon. Not only does this result in extremely long and dimensionally shaping shadows falling from your subject matter, it also produces a warmer light that emphasizes the reds, yellows, and oranges in an environment or on a subject. Why? Atmospheric debris is denser as it gets closer to the earth's horizon, and light from the sun has to pass through more of that debris during the golden hour. This debris—dust, pollution, clouds, and other fine materials in the sky—diffuses the intensity of the light and tints it with (usually) a shade of red or orange that is noticeable in your shots. This tinting does not normally occur at high noon, because at higher angles, the sun's rays only have to pass through a small layer of debris as they head down to Earth, unlike at sunrise and sunset.

The golden hour is ultimately about the color of the light, hence the name (**FIGURE 7.1**). It makes sense that this type of light is often sought after by land-scape and wildlife photographers. It bathes the land

FIGURE 7.1 Early morning light skims beneath the dense clouds above and shines on the mountains in Big Bend National Park. The rich earth tones are emphasized during the golden hour.

ISO 100, 1/100 sec., f/2.8, 115mm lens

FIGURE 7.2 Golden hour light can add drama to portraits, especially if the subject is dressed in colors that already pop (opposite page).

ISO 200, 1/320 sec., f/2.8, 200mm lens

in amber hues, saturating earth tones and diminishing the dynamic difference between shadow and light. This prized light, and the color it produces, is why these types of photographers wake up earlier than most others and will replace a home-cooked dinner with a granola bar—for only two hours, give or take, of light a day.

However, the golden hour isn't just for landscape shooters. Wonderful environmental portraits are made at this time, as well as just about any other type of image (**FIGURE 7.2**). One thing you'll notice about images created at this time of day is the way color pops. This isn't over-processed color. It is a naturally produced color that seems to reveal its true nature even more. Light and color at these times are dramatic, and a wonderfully backlit portrait or action-filled sports shot benefits just as much from this extra dose of color as does a shot of a desert mountainscape.

THE NOT-SO-GOLDEN HOUR

What about obtaining color in the middle of the day? During this time, the quality of the light changes radically. Many photographers consider the type of daylight that occurs between the golden hours to be tremendously weak, and I know several who will not even pick up a camera with serious intent at this time. For some of us, this cuts out quite a bit of time in the day for shooting, particularly if we are traveling or on assignment for a client who needs as much shot as possible in as little time as possible.

Colors during the middle of the day are more illuminated where light is hitting them directly, making the brighter colors even brighter. If bright is a concept you are going for in your images, then explore color during this time of day. However, keep in mind the level of contrast the light creates during this time. When you're exposing for lit areas, shadows grow deeper, resulting in dimmer colors, and in some cases, lack of color richness overall.

Your camera's limited dynamic range in capturing widely divergent lighting values can make this time of day tedious when you're shooting for maximum color. The great difference between light and shadow at this time can easily force exposures into blown-out highlights or blocked-up shadows, both of which can contain quite a bit of color. Instead of giving up on a location in between golden hours, I lean more toward shooting in the shade during the middle of the day, where I don't have to push my camera's sensor beyond its ability to handle light.

FIGURE 7.3 Direct sunlight in the middle of the day brings harsh, deep shadows. Soft, consistent open shade allows the bright southwestern colors of Santa Fe to shine (opposite page).

ISO 100, 1/250 sec., f/8, 66mm lens

FIGURE 7.4A Harsh, post–golden-hour light directly hitting a yellow coreopsis. Shadows are bold and hard, and the color doesn't show much of the flower's delicate structure (above right).

ISO 100, 1/250 sec., f/8, 66mm lens

FIGURE 7.4B Throw a diffuser between the sun and the flower, and you have open shade lighting. Colors are more even and detailed at this perspective (below right).

ISO 100, 1/250 sec., f/2.8, 85mm lens

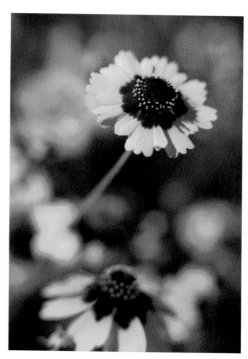

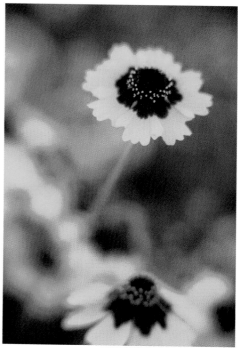

Shooting in complete shade during the middle of the day isn't a new concept for photographers, especially those more focused on portraiture. We shoot in the shade to negate the often harsh effects the high light contrast has on our subject matter. Not only is shooting in more even light conducive to maintaining exposure and detail, it also allows for consistent, more accurate color rendering (**FIGURE 7.3**). When shooting in the shade, you are essentially shooting with few if any shadows. Although some contrast is good for the creation of depth, diffused light allows the photographer to really study color and create a different type of feeling in an image.

Every year, I photograph the flowers that abound in the Texas Hill Country in springtime. If I want to get tight on flowers and shoot close-up, macro images, you'll find me in the shade of a building or using a diffuser to block harsh light at any time of the day, just as if I were shooting portraits (**FIGURE 7.4A** and **FIGURE 7.4B**). The light disperses, softening the shadows on the petals, and I can concentrate on showcasing that color without the distraction that deep shadows create on other parts of the scene. I'm even happier if I get to shoot the same subject matter

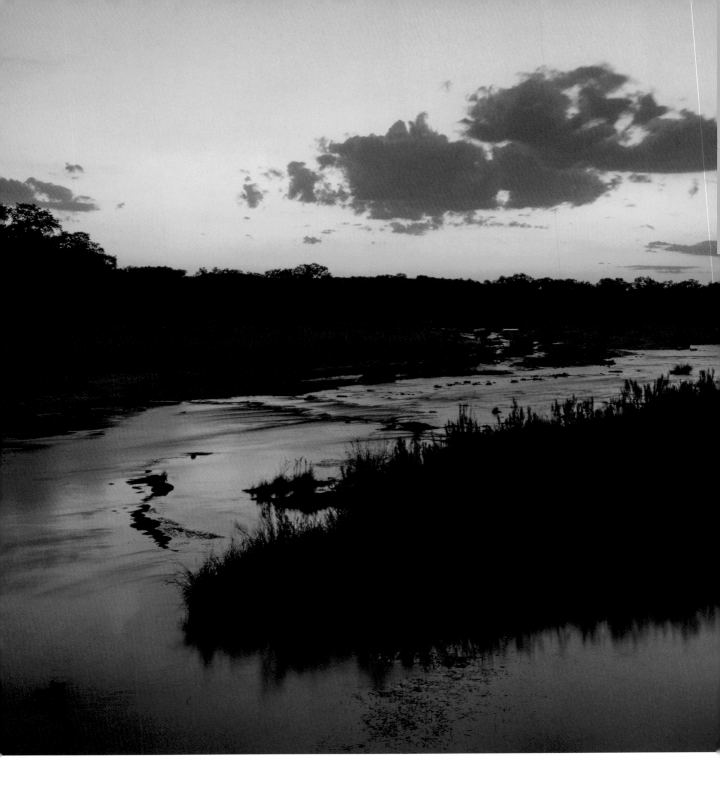

in fairly overcast conditions. I have heard more than one photographer say that an ideal day's weather would be clear to partly cloudy during the golden hours and overcast for the remainder of the daytime hours. They are talking about shooting with ideal light, and with light comes color.

THE BLUE HOUR

The blue hour is all about those moments before the sun rises or after the sun sets. I know it sounds like torture—getting up extra early to shoot during the hour before sunrise—but the more subdued light helps reveal another personality for any environment. At this time, often dark yet pastel-like colors dominate a scene.

During the blue hour, indirect light from the sky reflects a cooler tint across an environment. As the sky slowly gains luminance, so does what is below it. This light is often dim, but details start to come out of the shadows, highlights begin to shimmer, and the day comes to life. Keep in mind that the sky is usually several stops brighter than what is below it during the blue hour, hence the tendency to shoot with very little sky in the frame. Getting on location well before the sky lights up is appropriate, since the light and exposure, and the resulting colors, change continuously. Long exposures over large or small bodies of water and landscapes often come to mind in connection with blue hour shooting (**FIGURE 7.5**).

FIGURE 7.5 The blue hour allows for long exposures over landscapes. The softer colors gradually populate the scene during exposure.

ISO 100, 20 sec., f/22, 42mm lens

FIGURE 7.6 City lights balance a graduated blue sky during the blue hour. Colorcasts for all types of lights are particularly distinguishable at this time of day.

ISO 800, 1/40 sec., f/4, 18mm lens

Precisely lit portraits also stand out when shot at these times, especially when the light hitting your subject is obviously different than the ambient blue hour tones. Another type of shot you might be familiar with that is done well during the blue hour is a cityscape at twilight (**FIGURE 7.6**). Light values in the sky often balance well with those of streetlights, vehicle headlights, and office building interiors. This balance frequently accentuates the colors of both the sky and the terrestrial lights, making them pop a bit more against a largely subdued background—that is, the rest of the city structure.

The blue hour resonates with calmness and peace, but not all blue hours are actually blue in nature. Depending on how you set your white balance, that naturally cool temperature of the light can easily be warmed up (more on this in Chapter 9). The point, though, is that this period of the day can still be used to obtain great color. We have to be aware of the subtleties of the light and color, but it allows us to seek out different iterations of color while being able to squeeze a bit more shooting time out of the day.

WATER

Living in an area of the world that doesn't have much water, I'm always excited to see a good rain or to visit running rivers and large lakes. When seeking out color, you'll find water useful in two distinct ways. The first is reflection: a body of water that reflects colors and subject matter. This is pretty simple, right? We've all grown up looking at puddles of water or ponds that mirror the sky and anything close by. You have more than likely even spent some time watching as someone runs through that puddle, disturbing the placid reflection until it returns to crispness. Well, now put that reflection to use.

Many times, the reflection in a body of water, no matter the size, is a solid color—blue. The ocean is blue in part due to the amount of sky above it, especially on a sunny day. At sunrise or sunset, though, the water may change color several times as the hues in the sky change, particularly during the blue hour (**FIGURE 7.7**). At other times, water may simply reflect a colorful subject matter, and the entire scene can be recomposed based on this reflection. In any case, composing this component of a shot can be the "splash" of color an image needs to either catch the eye or tell part of the story about your subject matter.

FIGURE 7.7 Colorful blue hour reflections are a go-to among landscape photographers.

ISO 100, 2.5 sec., f/22, 50mm lens

SHOOTING REFLECTIONS

Reflections may also offer up another creative way to display your subject matter (**FIGURE 7.8**). The next time you are shooting, say, a street scene, look for any water puddled up. Shoot the colorful subject matter only as a reflection. Color reflected in water shimmers and is visually intriguing. It offers you another vantage point for your shooting, and it flexes your vision a bit while you're on location.

It also flexes your shooting technique. If you are initially shooting with an aperture value that offers a relatively shallow depth of field, such as f/4 or f/5.6, don't be surprised that focusing on subject matter in a reflection results in the street appearing out of focus. Since the subject matter in the reflection is farther away than the street containing the reflection, the need for a more closed-down aperture to gain depth of field is warranted. Stop your aperture down to f/11 or f/16 if you would like to gain focus for all of the frame.

FIGURE 7.8 Golden hour reflections of the Temple of Debod in Madrid, Spain. A nice way of taking advantage of two relatively saturated, vibrating colors.

ISO 50, 1/8 sec., f/22, 47mm lens

The second variation on how water helps bring out color is through moisture that hangs around after a rain shower or storm or during a morning dew (**FIGURE 7.9**). Many people starting out in photography see rain as a stop sign on their activities. Don't let a good rain get in the way of shooting afterward. When the dust has settled and a few drops are still hanging on everything from plants to park benches, take advantage of what this does for color. Moisture reduces the atmospheric haze and boosts the vibrancy of many colors, especially those that are less muted, such as light greens, yellows, and reds. Landscape photographers love rain for this very purpose. Macro photography work seems more exciting with the light dew on flower petals or blades of grass, along with the saturation of colors the moisture brings on. Street photographers also appreciate a rain. Pollution in the air is diminished, and the glistening of wet geometrical edges often complements colorful walls that just received a wash. All of this goes to say: Enjoy the rain when it happens, and go make colorful pictures after it ends.

THE SKY

Entire books have showcased the world of color that exists only in the sky, and for good reason. The sky can make or break an image, and much of that has to do with its colorfulness. Who among us doesn't like a good sunset or sunrise, or simply a rich blue sky paired with a well-lit subject? The sky is a very large and hard-to-miss contributor of color in your imagery. Just as with the golden hour, much of the sky's color comes from what actually composes the atmosphere, but it helps a photographer to know how to take advantage of the most color possible from the "heavens above."

Timing is essential in procuring colorful skies (**FIGURE 7.10**). Typically, the lower the intensity of the ambient light, the more apt you are to achieve decent color. Practically speaking, the golden hour is not only

FIGURE 7.9 A daytime rain shower is never an excuse to put away the camera. Look for great color among the greens and yellows of the vegetation, which will differ from their previous dust–covered versions before the shower (opposite page).

ISO 100, 1/160 sec., f/2.8, 120mm lens

FIGURE 7.10 The desert is not known for its midday color. I spent four hours getting to one shooting location for the Chihuahuan Desert Bike Fest and positioned myself to capture a northern sky, where the blue is typically the most intense.

ISO 400, 1/1600 sec., f/8, 24mm lens

good for color across a landscape, but the color of the sky will also stand out during this time as long as you are not pointing your lens toward the sun as it is rising or setting.

Speaking of pointing your lens away from the sun as it rises or sets, the further north you point your lens—that is, if you live in the northern hemisphere—the more likely you'll capture a great blue sky. The opposite applies if you live south of the equator. Blue skies are attractive in many photographic circumstances, and taking advantage of the bluest you can capture might add another dose of color to an already interesting image.

Clouds

Before the sun rises or after it sets are great times to start navigating your lens back toward the area of the sky where color will become the most rich. Shooting sunsets or sunrises is nothing new, and we do it mostly for the color, but it is worth saying that with enough patience we can wait out some even more incredible color in the sky at times. What makes a sunset even more interesting? Structure—clouds—in the sky. Clouds can certainly add another dimension to the palette of color in the sky. There's no good way to predict what colors might come from a sunset, but there's also no simpler—and often more compelling—way to convey color than with clouds at sunset (**FIGURE 7.11**).

FIGURE 7.11 A typical West Texas sunset. Colorful structure in the sky can empower simple silhouettes.

ISO 100, 1/60 sec., f/5.6, 35mm lens

Natural Colorcast

One more key facet of colorful skies to consider is how they also color the land and structure beneath them. No matter what tone or hue, the sky will always provide a tint that will either result in an interesting play on the terrestrial world or need to be adjusted with your camera's white balance (more on this later). The colorcast a sky provides is not something to overlook; it can often be useful. An open blue sky might not seem to render much coloration on a land or cityscape, whereas a warm red or orange sunset might boost an image of city building window reflections. The sunset could even provide an interesting kicker light to a portrait of a subject that needs some separation from an otherwise uninteresting, unlit background devoid of detail (**FIGURE 7.12**).

FIGURE 7.12 For this portrait of photographer Trace Thomas, the red kicker light is provided by the colorful western sunset. The red helps draw the viewer's eye and distinctly separate the subject from the background.

ISO 100, 1/30 sec., f/2.8, 24mm lens

SEASONS

I teach one university photography course that repeats each semester—one in the fall and the other in late winter/early spring. Depending on where students choose to shoot, I can predict that the fall course will offer up more colorful images than the winter/spring course. This has much to do with the overall color of the environment during those seasons. Winter is usually pretty bleak and monochromatic, while the fall is associated with earth tones and is full of vegetation going into dormancy, resulting in a lot of golds mixed with greens, as well as oranges and browns. Combine those fall colors with the type of light you see during the golden hour, and you have color that leaps from the image toward the viewer! Ultimately, in my part of the world and in others, the fall is a much more colorful period of the year than winter.

Now, if all this seems geared toward landscape photography, consider the colors you see on a daily basis during all seasons in more urban environments. Spring tends to be fairly colorful in the United States, as plants and animals start to grow or emerge from winter (**FIGURE 7.13**). Bright, cheerful colors, such as greens, yellows, oranges, and reds, tend to continue on through the summer (**FIGURE 7.14**), and they begin to mute in the fall with those darker hues of reds and dark and light browns (**FIGURE 7.15**). As much as we probably need color during winter from a psychological perspective, this season is not too colorful in urban or rural outdoor settings. Steely blues, blacks, and whites are the colors typically associated with the colder months (**FIGURE 7.16**).

FIGURE 7.13 Springtime is about growth, and emerging pink–white blooms on a crab apple tree are a sign that winter is gone.

ISO 100, 1/320 sec., f/2.8, 95mm lens

FIGURE 7.14 A magazine cover shot called for bright summer colors to convey what the season is all about: fun!

ISO 200, 1/100 sec., f/3.2, 100mm lens

FIGURE 7.15 Seasonal color is strongest in the fall, when leaves turn and wreaths made of the same earth tones and materials are hung on the doors of homes and businesses.

ISO 100, 1/125 sec., f/5.6, 170mm lens

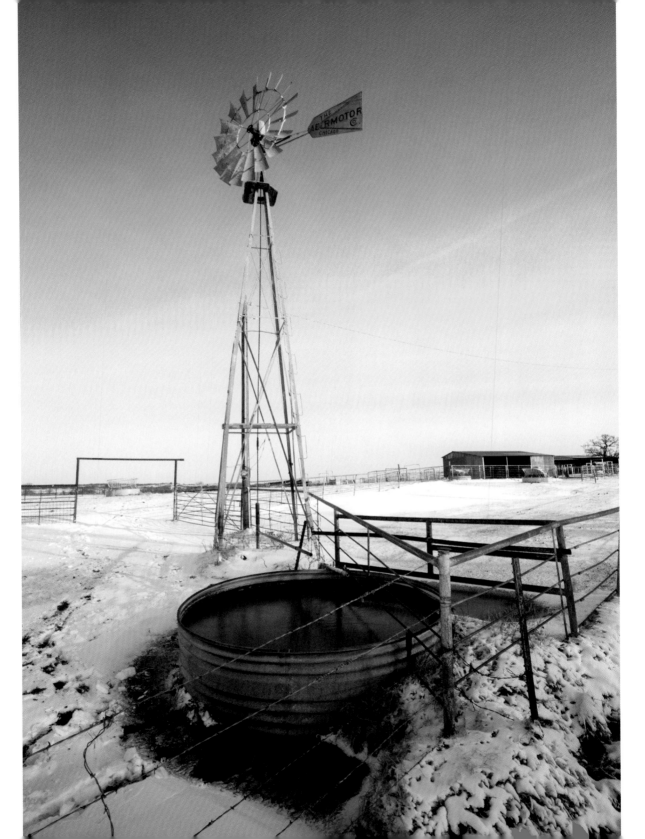

Natural, ambient light changes according to the season. In West Texas, the fall produces a warmer light in part due to the increased agricultural activity in the area—the stirred-up soil in the air forces yellows and oranges to hang on longer in the evenings. Winter light seems more brisk, and the golden hour seems to diminish more quickly due to cleaner air conditions and less colorful land and structure.

Check out the colors of the seasons where you live or work—they might be quite different from what I'm used to seeing. When it comes to color that varies by season, it is ultimately about paying attention to how color emerges over longer periods of time—annually, to be exact. You might find great color stands out relatively quickly after a rain shower; seasonal color is something we learn to explore as time progresses in an almost cyclical pattern over an unfolding 12 months.

ARTIFICIAL LIGHT

Artificial light, especially indoors, is a great contributor to the color we see and photograph. Chapter 8 highlights how we as photographers can augment color using artificial light. This section, however, encourages you to be vigilant about how existing ambient artificial light can affect color.

Environmental Color

Picture yourself walking into the local pub or dance hall. A well-appointed coffee shop will do as well. Look at everything around you, paying special attention to how the place is lit. See any bright green, blue, or red neon lights? How about stage lights with color filters? What is the color of light that is hitting that old, lonely disco ball hanging from the ceiling? You're more than likely in an environment where those types of accent and novelty lights dominate the place's ambience, and for good reason. These kinds of lights, in all their colorful variations, provide a sense of the space to the patrons. Even the streetlights outside might help colorfully decorate the environment, especially at twilight and on into the night.

The next time you are in or around one of these places, take a look at how all of the colors exhibited by these lights glint off the edges of tables and chairs, or how they light up a particular area where people socialize or perform, such as a live music venue's stage. Some of these lights are in your face, like those

FIGURE 7.16 Winter scenes, especially at higher elevations and in northern latitudes, offer scant color. By taking advantage of the golden hour and a northern sky, photographers can find color in the monochromatic landscape (opposite page).

ISO 100, 1/100 sec., f/16, 17mm lens

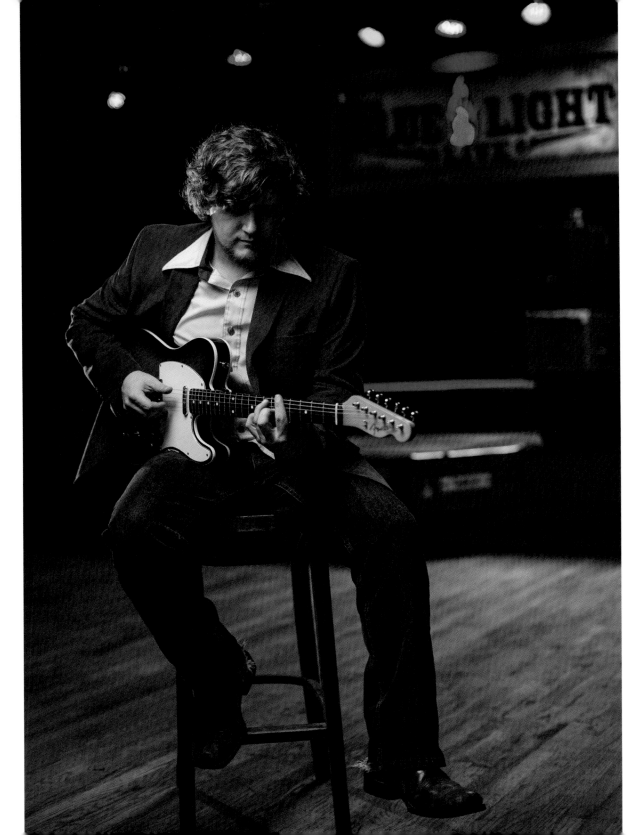

illuminating the band (**FIGURE 7.17**). Others are less intense and convey the term "accent light." The colors cast by such lights in places like this provide an attitude and personality that complement your photography. They help tell your visual stories.

You might, of course, assume that bars and coffee shops are going to be lit and colored in a way that conveys a mood appropriate for the venue. Bars and dance halls are lit dimly, but most of the colors are bright enough to direct a viewer's attention toward what the neon signs are selling. Coffee shops are lit in a way that keeps the personality of the place more intellectually mellow, with warm, soft yellow and white light. But what about other environments that use artificial light but are not trying to convey as specific of a mood? What if the colors of the lights are not as striking or attention grabbing?

Color Temperature

Keep in mind that all artificial light has a color temperature, and therefore a colorcast. In some environments, such as an office or a living room, the color produced by an artificial light source such as a floor lamp might highlight just the right amount of color needed in a shot to either compose with or help provide a sense of the environment. Practically speaking, I am constantly scanning a room for lamps, wall sconces, and any other artificial light sources apart from the overhead lights when I am assigned to photograph an environmental portrait inside. If the light sources look great for the image, I might incorporate them into the shot—not only for their drop of color, but also for their potential to provide a colorful hair or kicker light for my subject. Although white balance is something we will discuss in more detail in Chapter 8, when treated creatively, it can cause light sources as simple as a desk lamp to become quite useful as well as colorful in the right setting (**FIGURE 7.18**).

Start training yourself to see the actual color of the lights themselves. Take, for example, fluorescent lights, everyone's favorite light to hate (or at least it used to be). Even though daylight-balanced flourescents are readily available at the local hardware store, many places you might find yourself photographing may still use those that cast a more green or magenta color. One can always correct for this easily with a flick of the white balance adjustment, but perhaps that green can come in creatively handy. Incandescent light bulbs, those found in many desk and floor lamps, as well as ceiling fixtures, exhibit

FIGURE 7.17 The stage lights and neons not only fill a compositional void, they also provide a colorful sense of place. You can hear the boots shuffling across the dance floor (opposite page).

ISO 50, 1/60 sec., f/2, 50mm lens

a warm yellow tone. How can this colorcast work for you? Ask yourself if it helps provide a storytelling ambience. I often let the yellow tone come through a bit, especially if I'm using that light source as a contextual component of the shot, as well as a second lighting source for portraits.

Some light sources provide unique color and tone to an otherwise bland environment, such as lamps, while others are more aggressive and purposeful in terms of color, such as concert stage lights. Pay attention to all of them and don't be afraid to snap an exposure or two to see how the lighting will turn out. Sometimes combining two or more different-colored ambient, artificial light sources can result in interesting images. Sometimes you just need a dash of color for the heck of it, and these light sources can provide it.

SCOUTING FOR COLOR

The next time you are scouting out locations to shoot, whether they be downtown or hundreds of miles from any sort of civilization, look not only for nice composition and how shadows are going to stretch off of subject matter, but how the color of the content itself, as well as the color of the light, will look after you push the shutter button. Consider how the environment in which you'll be shooting will fully exploit the color within your frame. Do you need to wait for a rain shower to pass before shooting inside a deep green forest? Would twilight, or the blue hour, be a more appealing time to expose the neon sign at the entrance of a local club, or should you opt for later in the night, when no color exists in the sky?

From scouting a day in advance to thinking months down the road, previsualize the potential color in images and plan out when, where, and how you will obtain it. Scout a location in the winter and anticipate how the fall color might look like in that particular place. Don't think just about the direction of the light; consider how it will create a final colorful rendering on your viewers' eyes—and your own. If you walk down a street and notice what could be a fairly colorful scene outside of a fish market, but the type of light you are working with is too high in contrast for the richness of the color to show through, keep that location in mind for the next time it is overcast.

FIGURE 7.18 Turn on all of the accent lights—lamps, sconces, even rope lights if they're present—when you shoot an interior portrait. The warm drop of orange above the subject's head comes from a great-looking fixture, and it adds an interesting boost of color to the image, especially since the frame is not white-balanced for the incandescent bulb in the room (opposite page).

ISO 200, 1/30 sec., f/4, 50mm lens

Affecting Color

To a great degree, we photographers are in control of color. We choose when to shoot and what light is used to influence the color of our landscapes; we select certain colors that would entice a viewer of the advertisement we're shooting; we choose whether or not to include a bright, distractingly colorful object in our feature images since it potentially takes away from our primary subject; and we even determine the meaning conveyed by color by conjoining it with an image's content.

ISO 400, 1/160 sec., f/2.8, 24mm lens

Photography is built on choices—choices influenced by a number of issues and inspirations. Some of these decisions take no effort; they're so engrained in the history and philosophy of photography that we simply gloss over them. Some, however, are purely individual. We can intentionally affect color beyond selecting a particular shirt for our model or shooting only during the golden hour. This chapter explores a few ways that you can manipulate color with the camera and gear you have in your bag—choices you might always be carrying around with you!

WHITE BALANCE

White balancing is technically meant to do exactly what it sounds like: remove any subtle, or not so subtle, colorcasts from an image in an attempt to ensure that anything that is truly white within the frame is indeed white. In turn, this compensates for any universal colorcast that affects all other colors in the frame, rendering "truer" color. This is a good thing, since many digital cameras have a slightly red or slightly green colorcast (although you might be hard-pressed to identify it with newer and newer technologies).

When you white-balance your image, you are essentially altering the color temperature of the light sources in an environment so that they align with our perceptions of what white is supposed to be. If you are looking to capture

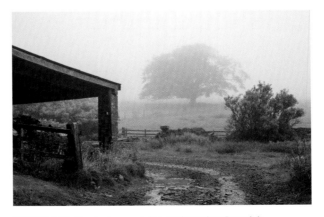

FIGURE 8.1A Fog before sunrise enshrouds a Scottish landscape. At 5,550K, the image is white balanced.

ISO 400, 1/40 sec., f/8, 55mm lens

pristine white where white exists—and subsequently more accurate colors—then setting your white balance appropriately adjusts the camera's amount of color temperature filtration to do so. This is often accomplished manually in studio and commercial settings with the use of a white balance card or color checker. Other photographic settings may only require using the white balance presets included in your camera that are relative to your lighting conditions. These presets are continually getting better, and I'm personally impressed with how auto white balance can accurately measure the color temperature of a given environment now compared to previous iterations, regardless of the camera manufacturer.

White balancing is only one way to adjust color temperature in an image, though. Chapter 5 spent quite a bit of time on the emotional impact various colors have on image viewers, and it highlighted these colors as specific elements of the frame. However, by adjusting our white balance settings on the camera,

we can influence the overall colorcast in an image to intentionally invoke similar emotions and appeal. This requires breaking away from the initial purpose of white balancing and embracing what different color temperatures might say about your shot.

Let's say, for example, that you are shooting a foggy landscape at sunrise (**FIGURE 8.1A**). At first, the fog is colorless, even though you anticipate the sun to spark the scene if it doesn't rise behind a dense bunch of clouds. You can at that moment warm the fog up by moving your white balance preset from Daylight to Cloudy or Shade (**FIGURE 8.1B**). You basically told the camera to add an orange filter to the image, similar to a traditional warming filter. This is only one way to alter the color and feelings conveyed by the image. What if you want something more icy or cold? Simply move the white balance preset to Tungsten or a custom temperature that cools the image down considerably (**FIGURE 8.1C**) to apply a blue filter (meant to compensate for the orange quality of traditional light bulbs).

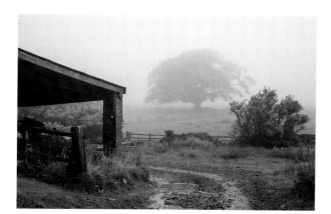

FIGURE 8.1B By adjusting the white balance to 7,000K, I warmed the image up considerably, evoking the notion that daybreak is not far off or that the sun is pushing through the dense fog.

ISO 400, 1/40 sec., f/8, 55mm lens

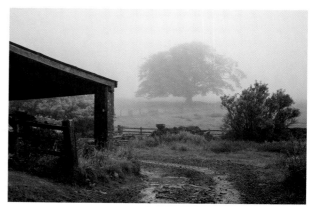

FIGURE 8.1C With the white balance set to 3,700K, the image now seems as wet and cold as the land I was looking upon.

ISO 400, 1/40 sec., f/8, 55mm lens

Since color temperature ranges along a familiar colder-to-warmer scale, we often look to alter it accordingly. In cooling images down, we tend to make them more blue. Doing so might convey a sense of that coolness—physically—depending on the environment depicted. A winter scene might be visually depicted as colder from a slightly blue colorcast adjustment on camera (**FIGURE 8.2**). Cooler color temperatures also provide a sense of time, such as nightfall. The cool colorcast signals the end of the day, a quiet period of time, and in some cases mimics what we think of as color for a moonlit evening (**FIGURE 8.3**).

Leaving our cameras in Daylight or Cloudy white balance after the sun sets actually renders colors more orange (**FIGURES 8.4A** and **8.4B**) and may portray a more negative than appealing tone. Cooling down the temperature brings on the feeling that it is nightfall, typically a physically cooler time of the day, and emphasizes the darkness of that time as well. Likewise, shots of lightning are given a new dimension when you cool the color temperature down. The sky becomes more steely, and the bolts themselves visually seem more, well, electric (**FIGURE 8.5**).

FIGURE 8.2 A color temperature that casts a slight blue over the scene reinforces the idea that it is cold on the ranch.

ISO 200, 1/125 sec., f/16, 24mm lens

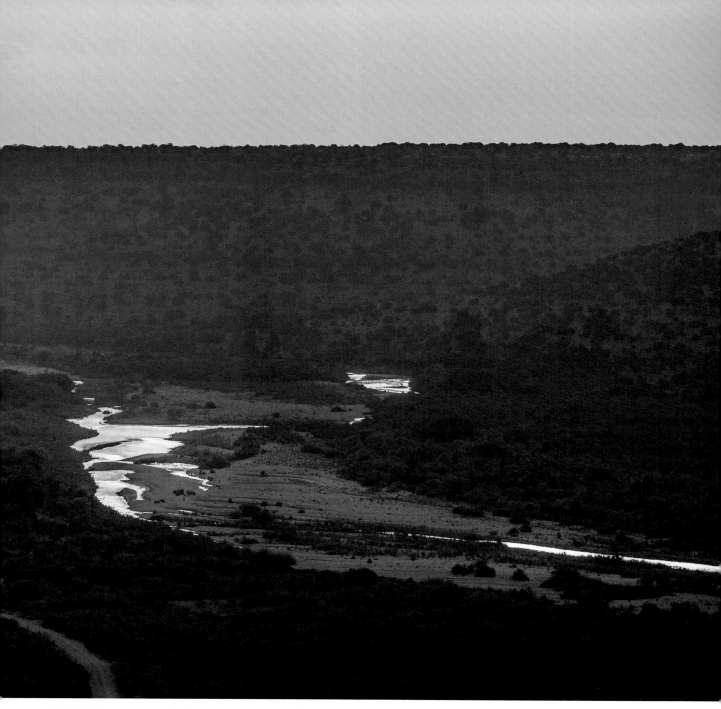

FIGURE 8.3 Tungsten white balance preset was used to further communicate the nighttime feeling of this image. It doesn't hurt that the creek below reflects the light of the moon.

ISO 200, 30 sec., f/5.6, 160mm lens

A

B

FIGURE 8.4 Figure 8.4a evokes feelings relative to a typical notion of nighttime, where as the more dull tan sky of Figure 8.4b is less appealing to the eye and mind.

ISO 200, 4 min., 48 sec., f/4.5, 24mm lens

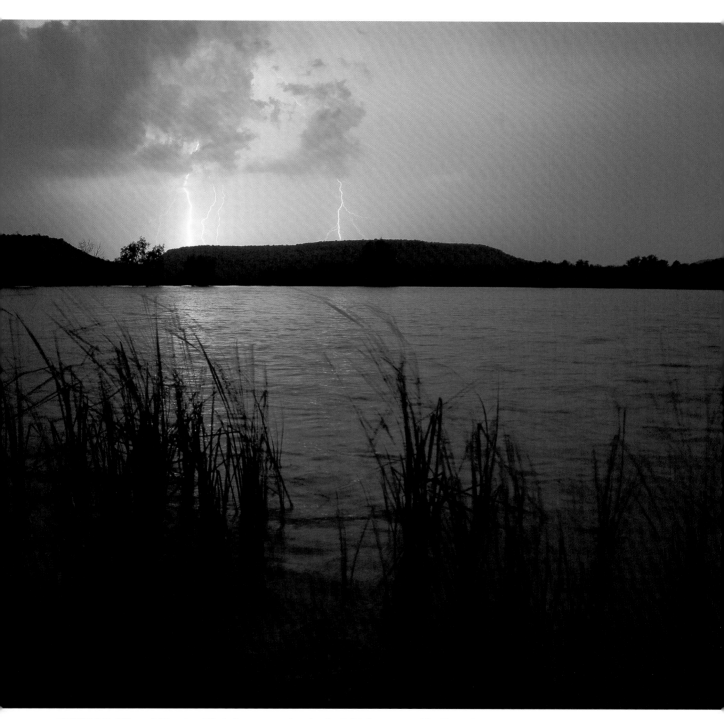

FIGURE 8.5 Although Cloudy white balances are also nice for lightning, a more blue Tungsten setting seems to make the bolts more white and the scene more captivating in some cases.

ISO 100, 22 sec., f/5.6, 17mm lens

A

B

FIGURE 8.6 Cloudy days can reduce the emergence of warmer colors, such as reds. Figure 8.6b pushes the reds in the granite forward as the result of a warmer color temperature.

ISO 100, 0.4 sec., f/22, 17mm lens

Warming the color temperature for daytime images introduces feelings of a different kind. Photographers tend to like warm colors—it's probably from natural light influences. If you are shooting in the middle of the day, when the light is rather bland and uncolorful, a quick way to introduce some reds to counter the gray blues dominant of the light at that time is to simply move from a daylight color temperature to one akin to a cloudy white balance (**FIGURE 8.6A** and **8.6B**). That's not to say that you can't do this during the golden hour as well. Warming up the color temperature might further exploit the nice light bathing your scene at the time—it can introduce a feeling of comfort (**FIGURE 8.7**). Like the introduction of a green colorcast, pushing the color temperature warmer and warmer also may introduce a feeling of illness or anxiety (**FIGURE 8.8**). Unlike calming or stable blues, introducing a more aggressive, global colorcast can create a sense of chaos.

The preceding suggests that large increases or decreases in color temperature can greatly affect the mood and context of the shot, and indeed they may (**FIGURES 8.9A**, **8.9B**, and **8.9C**). However, global color temperature changes are sometimes more powerful when they are subtle, especially when the image you are planning to make is of one dominant color (**FIGURE 8.10**). Large amounts of change with an image composed of a diverse mix of colors may not provide the results you hoped for (**FIGURE 8.11A**). Tweaking the color temperature just a bit might add the right amount of color change and emotional intrigue (**FIGURE 8.11B**). You'll just have to see for yourself. Like many things discussed in this book that relate to emotion, the right colorcast might depend greatly upon the content in the shot, and this is where experimentation comes in handy.

FIGURE 8.7 Great evening light can be made even warmer by using a color temperature that is higher on the Kelvin scale than the average Daylight white balance preset (left).

ISO 200, 1/320 sec., f/4.5, 200mm lens

FIGURE 8.8 In an attempt to warm up the noon lighting, I used a color temperature in this initial shot of a corn farmer in the Texas Panhandle that many would say is a bit too orange (below).

ISO 100, 1/125 sec., f/11, 17mm lens

FIGURE 8.9 The heavy-handed use of global colorcasts as a result of color temperature changes the mood of the portrait along with the lighting. Figure 8.9a and Figure 8.9c say very different things when compared with a properly white balanced Figure 8.9b (right).

ISO 100, 1/100 sec., f/7.1, 165mm lens

FIGURE 8.10 When looked at as abstract colors, this shot is made up of largely similar tones. A subtle boost in the image's warmth enhances the already warm nature of the playful light (opposite page).

ISO 200, 1/640 sec., f/2.8, 70mm lens

A

C

B

FIGURE 8.11A A color temperature that is too warm can make the skin look jaundiced and other important colors, such as the blue of the cooler, seem washed out.

ISO 100, 1/60 sec., f/5.6, 17mm lens

FIGURE 8.11B A milder color temperature renders the colors more accurate.

ISO 100, 1/60 sec., f/5.6, 17mm lens

Controlling the color temperature of your image is done manually in two different ways. So far, I've discussed it in terms of changing your color temperature, or white balance, settings *on* your camera. You can choose a white balance preset that is loaded on your camera, or you can create a customized preset by manually adjusting your color temperature within the camera's menu system. (Now, where's that dang camera manual?)

The second way to control your image's global color is by adjusting its color temperature using post-processing software. Shooting in a specific file format allows you great flexibility in adjusting color in post. Even if you are new to photography, you have still more than likely heard about the Raw file format and some of its many benefits. One of them is the ability to adjust the image's color temperature with the same type of control you have on your camera, while still maintaining the integrity of the original file (in other words, you can play with the image, and if you don't like the results you can go back to the original).

Raw file readers, such as Adobe Camera Raw—which is included in popular software applications such as Adobe Lightroom, Bridge, and Photoshop—let you adjust the image's color temperature in reference to the Kelvin scale (think back to Chapter 2). Software that comes from the camera's manufacturer should let you do the same. Most applications also allow you to adjust the image's tint along a magenta/green sliding scale for even more nuanced control. When you want to affect your image's emotional and contextual appeal by introducing a global colorcast, adjusting your Raw file's color temperature in post also lets you see the change occur right before your eyes. You're able to experience a continuous range of color temperatures with the efficient movement of a slider,

and you can stop when you reach the particular color temperature you desire.

Even if you are simply white-balancing in post or making more-than-subtle changes to your image's overall color to evoke certain feelings, this post-processing tool finds its value quickly. Keep in mind that you can also adjust the color temperature of other file formats, such as JPEGs, but they do not have quite the controllable and nondestructive flexibility that Raw files do.

ARTIFICIAL LIGHT II

The last chapter highlighted how different light sources, such as incandescent light bulbs, emit different color temperatures based on their construction and function. This discussion was centered on light that exists in a given environment in which you are shooting—largely uncontrollable light sources that may or may not be advantageous to you from a color perspective. Of course, these are not the only artificial light sources at a photographer's disposal.

When most photographers hear the term *artificial light*, they think immediately about strobes, speedlights, and sometimes reflectors. Unlike artificial light that is pre-existing in a shoot, these types of lights are highly controllable and easily manipulated from a color perspective. Before doing so, though, one piece of information is essential: the current color temperature of the light you intend to use. Where does your strobe fit on the Kelvin scale?

Most flashes emit light measuring between 5,000K and 6,000K, and many rest somewhere close to 5,500K. Manufacturers construct them this way to emulate the color temperature of direct daylight. Of

FIGURE 8.12A A formal portrait of a university president and his wife made while using a color correction gel on a pair of flashes.

ISO 800, 1/50 sec., f/5.6, 60mm lens

course, the most accurate way of determining the color temperature of your specific light is to measure it using a color temperature meter. If you're like me, you typically don't have the time, or the cash, to do so. However, it is critical that you obtain from the manufacturer the approximate color temperature of your lights. One of my go-to lighting systems is the Elinchrom Ranger Quadra setup, and the flash heads in this kit are rated close to 5,500K. This tells me how they may look under ambient light conditions in a variety of environments, as well as what I need to do to augment the color emitting from the light itself.

Speaking of augmenting color, the surest way to do so with flashes and strobes—without necessarily affecting the color of the entire frame by changing the on-camera white balance—is by using colored gels. Technically, gels are transparent colored filters that closely resemble small pieces of cellophane or the transparency sheets once popular for school classroom use. Gels come in all shapes and sizes (some of which are the DIY variety), and they can be found in many different colors. You can find gels that fit just about any light source, and if you cannot, it's not too difficult to accumulate the materials necessary to make your own. Some flash units, such as the higher-end Nikon Speedlights, come with their own gels. For what it is worth, I'm a fan of the Honl line of products for my Canon Speedlites, but just about any brand you come across will work.

Using gels is fairly simple: Place the gel in front of the light, fire the flash, and voilà, a different color is born. Those that are referred to as color-correction gels are intended to balance a flash that is rated at approximately 5,500K with ambient light sources that reside somewhere else. Many incandescent light sources are close to 3,200K; to achieve a balance between

these sources and a flash, you would first set your camera's white balance to Tungsten or Incandescent (which will render the existing incandescent bulb white, instead of yellow/orange, but the flash blue), and place a warmer gel on the flash to bring it up to white (**FIGURES 8.12A** and **8.12B**). By doing so, you are balancing out the color of the two light sources. Many photographers, myself included, use gels mostly for this purpose. This is extremely useful for portraits in order to avoid odd skin tones created by using light sources that throw off different colors.

There is no law out there saying color balancing is the only use for gels, though. In fact, plenty of photographers are creatively using gels to do exactly what changing the white balance on a camera can do, or what introducing

FIGURE 8.12B A behind-the-scenes look at the lighting setup and ambient lighting. The flashes were gelled with 1/2–CTO (color temperature orange) gels to balance their light with the incandescent light sources in the ceiling fan.

ISO 800, 1/50 sec., f/5.6, 24mm lens

FIGURE 8.13 A light green gel was used to light the model, to boldly differ from the warm light covering the old church in the background, and to provide a bit of mystery to the story behind the image.

ISO 100, 2 sec., f/2.8, 46mm lens

a specific color that stands out in an environment can do: evoke emotion and provide mood to context (**FIGURE 8.13**). They also offer a bit of technical interest to the image—adding a touch of color is visually attractive. Remember those singular colors discussed in Chapter 5? Gels come in all of those colors and many variations in between, and they can also be used to conjure up feelings like those discussed earlier. Blue gels can be used to cool down— physically and emotionally—a subject in your shot (**FIGURE 8.14**), whereas an orange gel might lend the warmth of a fire to an image (**FIGURE 8.15**). The use of gels is limited by only what you can imagine. Photographers like Joe McNally and Gregory Heisler are well-known for employing gels in ways that sculpt out stories at the same time they grab attention.

One of the great things about flashes and strobes is that they are extremely mobile and adaptable to the environment. You can fit them in small nooks, hide them behind people in a frame, fly them high on a boom, or hold them in your nonshooting hand as needed (**FIGURE 8.16**).

GEL TERMINOLOGY

One of the reasons we use gels is to provide authentic-looking color to a frame. Rarely is light truly white in any given environment, and our eyes recognize this. When I use gels in, say, a room lit by incandescent bulbs, I often don't tune my white balance down all the way so that the light those bulbs emit is completely white. I like them to remain a bit warm, since that is how our eyes see them anyway. Likewise, after I roll back the color temperature, I will use a slightly warm gel to provide the same type of warmth to my portrait subjects. In the end, I come away with a portrait that looks as if it's lit the way we actually see it.

Depending on the shooting context, a number of commonly used gels can be quite valuable to your lighting. The most popular gels are probably those identified as CTO, or color temperature orange, gels.

Most come in ¼ CTO, ½ CTO, and full CTO, which refer to the amount of transparent orange each contains. A full CTO is a rich orange, whereas a ¼ CTO is considerably more transparent.

CTO gels are often used to warm up light and work really well with skin tones. They are not the only colors used extensively, though. CTB (color temperature blue) gels come in the same variations, as do green gels. CTO, CTB, and green gels are considered color-correction gels, which are meant to balance flash systems with different ambient lights. Theatrical color gels include other colors, such as purple, teal, red, and pink. All, however, can be used creatively given the right conditions and the right eye for color, even if that use is only to to emulate the type of light we physically see in a specific environment.

FIGURE 8.14 A blue gel served as a kicker light to provide a bit of edginess to the portrait's attitude and to complement the rather warm nature of the key light.

ISO 400, 1/160 sec., f/5, 105mm lens

FIGURE 8.15 A full CTO (color temperature orange) gel was used to light the owner of Cagle's Steaks. Although a noticeable fire would mean burnt steaks, the warm light hitting the chef lends itself to conveying the warmth of the grill.

ISO 100, 1/160 sec., f/2.8, 24mm lens

FIGURE 8.16 A small gelled strobe is easily placed in tight areas such as this cave, which, when lit, colorfully helps create dimension in terms of depth and color.

ISO 100, 1/50 sec., f/4, 17mm lens

What does this mean for color? Color is just as mobile and adaptable with these tools in play, and your ability to create a unique frame based largely on color is again somewhat limitless. Artificial light sources make it easy for us photographers to direct where the light—and subsequent color—goes in a frame. Think about live-venue stage lights. They are essentially gelled spotlights. The same effect can be achieved with the use of a small flash, a gel, and a homemade snoot. It is also fairly easy to combine two or more flashes in a frame, which means that you have more control over what colors can be introduced to the shot. Want a simpler artifical lighting device? How about a handheld spotlight used for light painting? Throw a gel on one of those, and operate it as a continuous light source that lets you splash color on the subject (**FIGURE 8.17**).

One thing to keep in mind when it comes to gelling flashes, whether they are small, low-powered strobes or heavy-hitting studio flash systems, is that overexposure will kill your color. If the power of the light source is too hot, the saturation of your colored gel will diminish. Reds become pink, blues will hardly be noticeable, and greens may go from a rich, nature-oriented appeal to a pale, sickly feeling. Consequently, if you are looking to lighten or desaturate the color you are emitting from a gel, this is a way to do so.

FIGURE 8.17 A warmed–up handheld spotlight is used to paint the church. Even though the church is white, the warmer light painting it provides an intriguing catch for the eye against the blue of twilight.

ISO 100, 1 min., 15 sec., f/5.6, 28mm lens

Using gels to do more than simply balance an ambient with an artificial light source means making an intentional choice as to the color present in your frame. It can contribute greatly to the appeal of your shot, and from a technical perspective, it is fun for us photographers to manipulate the technology we use. Experimentation will always be your best friend as you become more familiar with using gels. Spend time getting to know how they interact with your flashes, and learn to troubleshoot any issues you have with them. Don't let the technology get in the way of telling great, colorful stories, but if technology is what is called for at times, then enjoy becoming familiar with this ever-popular artificial lighting technique.

EXPOSURE

Maybe less so these days, but exposure has long been seen as one of the most intimidating technical elements of photography. My favorite filmstock, Fujichrome Velvia, had less than five stops of latitude in exposure, meaning that when the light and contrast extremities were just right—kind of like having all the moons in line—you still had to be dead on with exposure. Otherwise, the highlights were blown or the shadows were too murky for even digital post-processing to recover. Nowadays, digital sensor technology has increased that latitude in exposure by several stops, and post-processing software allows us to exploit even more exposure headroom in digital files. One thing that has remained the same, though, between film and digital, particularly at the moment of image capture, is that exposure affects color. Specifically, exposure affects the saturation of colors in the frame.

I hated overexposing film. Blue skies would quickly wash out to white, and colors seemed thin and unenticing. However, if I underexposed a shot by, say, a third of a stop, the colors would often become richer. Greens might become lusher, reds were deeper, and of course, those blue skies would pop nearly as much as the reds! Shooting a great West Texas sunset might sometimes necessitate underexposing the light in the sky by an additional stop just to saturate the colors that much more (**FIGURE 8.18**).

FIGURE 8.18 As a result of its extremely small exposure latitude, underexposing Fujichrome Velvia by one-third of a stop or more would make already aggressive color really pop!

ISO 100, 1/250 sec., f/2.8, 17mm lens

FIGURE 8.19 As a result of properly exposing the white lettering on the museum, the blue sky was underexposed and greatly saturated.

ISO 100, 1/200 sec., f/16, 17mm lens

Although digital photography is not chemical-based and is presumably more accurate in capture exposure, overexposing and underexposing have the same effects on the image (**FIGURE 8.19**). It should be cautioned that as with overexposure, it is easy to take underexposure too far. There is always a point of no return, and subtlety goes a long way. A third of a stop underexposure might not seem like much, but it might be enough underexposure to richen the greens of a dark forest or deepen the purples of a twilight sky.

The main thrust of this chapter concerned how we can easily affect color before taking our images into post, although I mentioned some functions of software applications as well. The gear we carry with us on a daily basis is extremely versatile. Even though a function of one part of the technology, such as digital white balance, was initially created to overcome an issue that plagued film shooters, photographers are creative problem solvers. If there is another function to be discovered of that tool, then we'll find it. Much of what was discussed here are techniques that you can practice any time. I encourage you to experiment with creating color yourself as opposed to simply finding it during a photo walk. The exercise will increase your technical aptitude for this particular part of the craft, and it will certainly enhance your appreciation for the use of color in your images and others'.

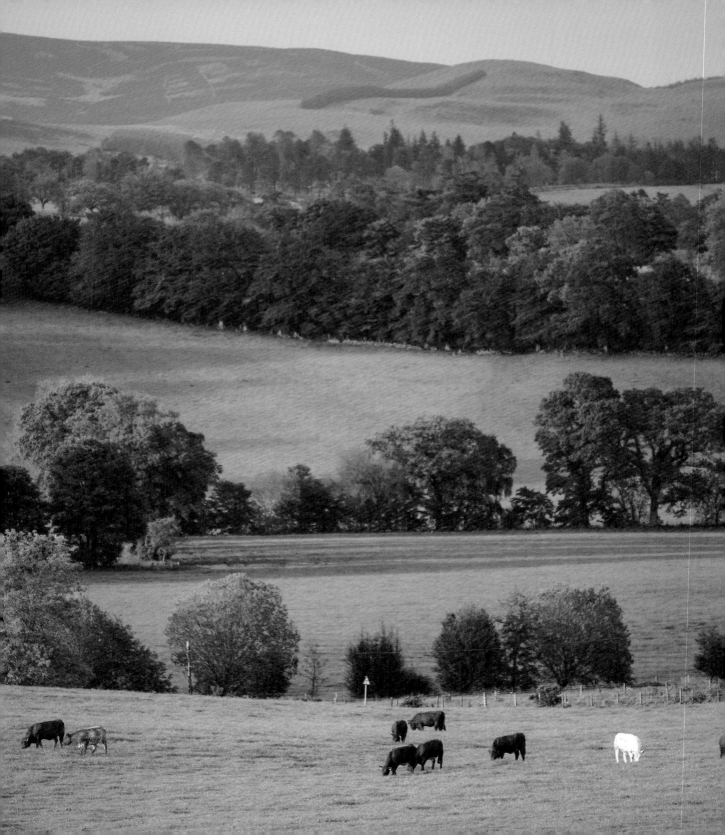

Making the Most of Color in Photography

The ability to photograph in color was revolutionary. Since the inception of color photography in the late 19th century, we have discovered quite a bit about it, explored Earth and its people with its new look, and translated it to the digital world. In a way, color photography reclaimed a nuance in color paintings and illustrations that was threatened by the realism of black-and-white photography. In the grand scope of history, it's still a relatively new way of telling stories and creating art.

ISO 100, 1/250 sec., f/2.8, 200mm lens

Color, in general, however, is not new. Whether we are color theorists or photographers, color will always draw our attention and appeal to us or occasionally repel us. Given that, and everything we've talked about in the previous chapters, let's highlight a few practical and technical tips to prepare you, the photographer, to take advantage of capturing great color.

BEST PRACTICES BEFORE THE SHUTTER CLICKS

I like to be in control. OK, that sounds bad. I like to be in control of all that I can when it comes to the image files I'm creating. There are a lot of things about my line of photography that you cannot control, such as the weather and sometimes the unexpected ambient lighting. However, one thing I always control is how well I'm set up with my camera to exploit the most color possible in any situation. In fact, every time I get a new camera, I set it up in such a way before I shoot even once. Not everyone's camera setup is going to be identical, but if you want as much control over your image as possible from a color perspective, your setup might look similar to mine. Here are the controls I establish.

Shoot in Raw

The first thing I make sure of when setting up a camera is to change the file format in which it is shooting to Raw. There are many upsides to shooting in Raw, including the most beneficial: a foundation for nondestructive editing. But beyond being able to process files without hurting their structural integrity, having quite a bit of latitude in exposure, and benefiting from a host of other post-processing control, using Raw files also gives you the maximum amount of information your digital sensor can capture (**FIGURE 9.1**). Compared with the JPEG file format (generally the only other file format listed as a choice on digital SLR cameras), Raw files capture nearly twice as much information.

For example, both the Canon 5D Mark III and the Nikon D800 create 14-bit Raw files, which equates to a total of 16,384 possible digital values for each pixel on the sensor. JPEGs are typically 8-bit files, which equals 256 possible values per pixel. A *bit* is the foundation for all digital information, and its on or off position represents the 1 and 0 in binary code. A digital image's bit depth

FIGURE 9.1 Shoot Raw to capture as much digital information as possible.

ISO 100, 2 sec., f/22, 17mm lens

is simply a number referencing how much file information exists in each image. In this case, the Raw file format is clearly the most encompassing. Multiply those numbers by three, since color files are made up of three color channels (RGB), and you have quite a few more possible values upon digital capture. That also translates to the possible color information. Technical reports state 14-bit Raw files are capable of capturing some 26 million colors, whereas an 8-bit file captures nearly half that.

So, what does this all mean for those of us who are not electrical engineers? Well, in a word: headroom. For photographers who post only to the web, 8-bit color suffices because the Internet is an 8-bit environment and will likely remain so for efficiency purposes. However, 8-bit files do not allow the post-processing flexibility larger bit depths do when it comes to making typical—and not-so-typical—adjustments. Having the headroom that larger bit depths offer lets us make exposure, contrast, saturation, and other color adjustments without muddying files up as quickly or losing digital information to poor software processing capabilities. For photographers making large prints, that headroom means being able to print at larger bit depths, negating the potential for rough color gradients (**FIGURE 9.2**) and the like in prints. And, as I tell all my students, processing technology and printing capabilities are always going to improve and take advantage of more digital information per file, so shooting in a higher bit depth file is also preparation for future capabilities.

FIGURE 9.2 Raw, 14–bit files contain enough digital information to reduce the potential of banding in color gradients, such as sunsets.

ISO 320, 1/640 sec., f/5.6, 400mm lens

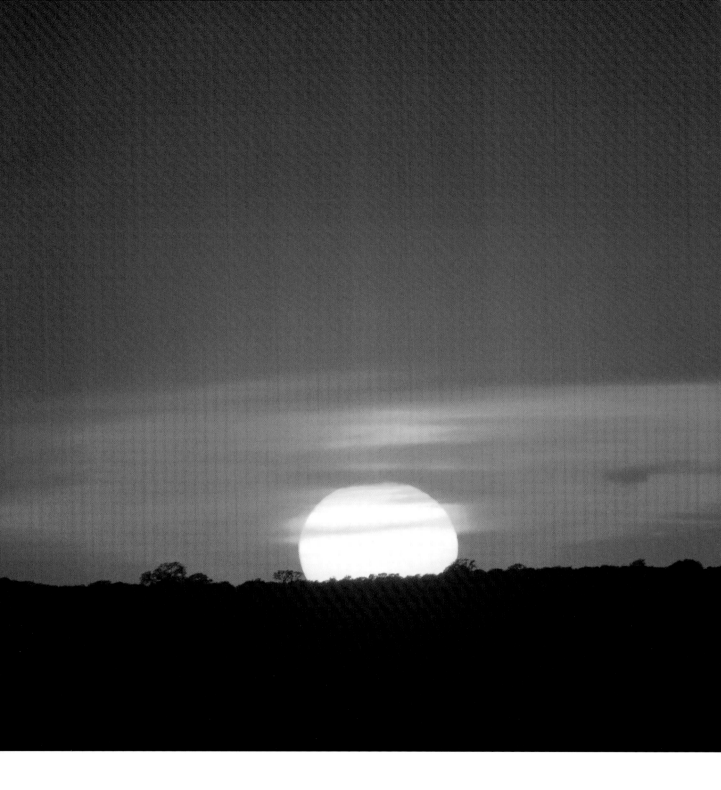

Use the Adobe RGB Color Space

The second thing I adjust on a new camera is the color space. Despite how much potential information we are able to capture (bit depth), the color space designates how much color is actually possible. Typically, we are given two choices: Adobe RGB and sRGB. If we looked at a chromaticity diagram for each of these color spaces, it would show us that shooting in Adobe RGB supplies us with a physically larger amount of color. Bigger is better, right? When it comes to color, yes. I'm very quick to change my camera's color space to Adobe RGB, whether I'm shooting Raw files or JPEGs. Principally, it is beneficial along the same lines as shooting in Raw and with a higher bit depth. The Adobe RGB color space is large enough to encompass both the sRGB *and* the CMYK color spaces, meaning that you can easily convert down to those spaces (**FIGURE 9.3**). Converting the other way around, particularly from sRGB to Adobe RGB, does not increase the amount of color available since it was never there.

Again, even if your primary medium for exhibiting your photography is online (synonymous with the sRGB color space), capture in Adobe RGB anyway to increase the potential the file has for converting to other color spaces. Keep in mind that on a typical computer monitor, the difference between Adobe RGB and sRGB is fairly indistinguishable, since most monitors display in sRGB or something close to it. Shooting in Adobe RGB is one of those behind-the-scenes principles that simply needs to be a given.

Keep in mind that shooting in Raw and in the Adobe RGB color space considerably increases the file size. Since the Raw file is completely uncompressed, the camera does not throw any information away as it does with a JPEG, leaving a hefty amount in place to be processed later. Likewise, since the Adobe RGB color space encompasses more color than sRGB, it packs more data into the file. Generally speaking, Raw files tend to be at least twice the size of a full-size JPEG (an average of 25 MB as opposed to an 8 MB JPEG off of a Canon 5D Mark III), but as a result, the photographer is left with gobs of information—especially color information—to work with in post.

FIGURE 9.3 sRGB and CMYK color spaces are similar in scope but encompass different color values. Adobe RGB, which includes values found in both, allows the photographer to convert down to the smaller spaces easily (opposite page).

ISO 1600, 1/200 sec., f/2.8, 95mm lens

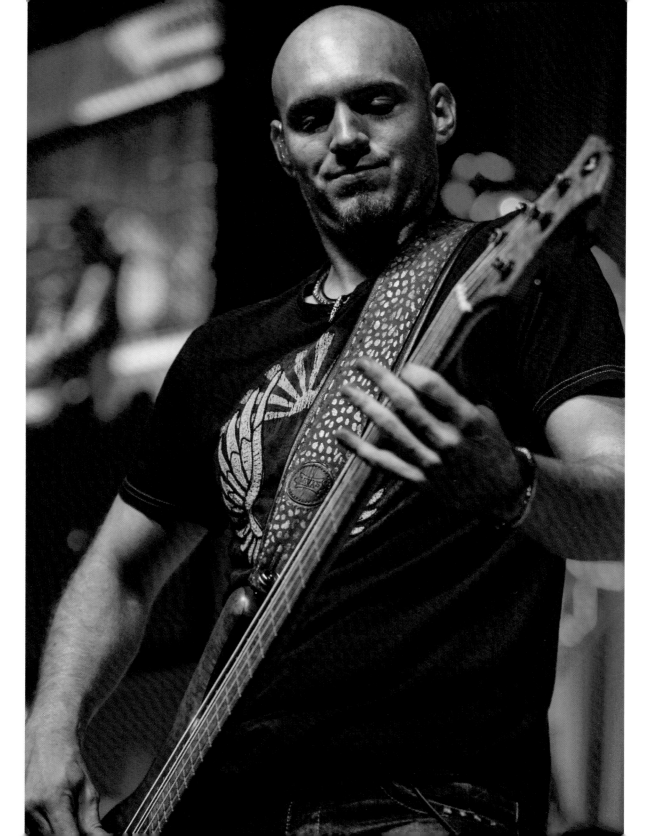

The Standard or Neutral Picture Style (Control)

Each camera manufacturer offers users a way to establish an overall look for images at the time they snap the shutter. Referring to these as creative controls, Canon's Picture Styles and Nikon's Picture Control functionality provide relatively similar coloration, contrast, and sharpening presets users can use (such as Landscape, Portrait, Standard, and Neutral). Raw file shooters are able to take advantage of these presets when they use workflow or post-processing software capable of reading the files appropriately. I used to be a big fan of the Canon Landscape Picture Style (**FIGURE 9.4A**). It seemed appropriate, given my leaning toward nature photography and environmental

A

B

portraits. I liked the boost in colors that somewhat emulated chrome film, and its heavier-handed contrast setting also gave a nod to the limited latitude present in many of the films I was using before switching to digital.

Eventually, though, I began to realize that I was falling victim to the style and not realizing the potential control I had over digital aesthetics related to color. Instead of letting the camera make stylistic decisions, I started using the Standard Picture Style (Nikon and other manufacturers have a comparable preset) (**FIGURE 9.4B**). Even though it is still a preset, it does not make as strong a color suggestion as Landscape does, allowing me to make my own decision in post if I so choose. The Neutral preset is even less suggestive (**FIGURE 9.4C**).

C

FIGURE 9.4A A Scottish Highland mountain stream shot using Canon's on-camera Landscape Picture Style. The style increases the contrast present in the image, as well as color saturation (opposite page).

FIGURE 9.4B Canon's Standard Picture Style keeps a relatively attractive level of contrast, but it reduces the amount of color saturation when compared with Landscape (opposite page).

FIGURE 9.4C Canon's Neutral Picture Style reduces both color saturation *and* contrast. Neutral images are usually described as flat, but they are a clean slate for post-processing work.

ISO 50, 1 sec., f/22, 24mm lens

As long as I'm shooting in Raw, I'm the least picky about this issue, knowing that the Raw file is more malleable than a JPEG. When I do shoot JPEGs, I typically leave Picture Style set to Standard. This is less behind-the-scenes than file format and color space, and it is also a very personal and subjective stylistic choice. Still, I feel I can actually see the potential in an image without as much manufacturer influence on my file. I would rather build onto an image in regard to color than to try to reduce or deconstruct it. Others may feel differently.

FIGURE 9.5 Low–light environments force a photographer to use high ISOs, reducing the straight out-of-the–camera saturation one might expect from the lowest ISO settings (opposite page).

ISO 1600, 1/50 sec., f/4, 24mm lens

Use the Lowest ISO Possible

With color film, it was common knowledge that the higher the ISO and the heavier the grain, the poorer the quality of color. The same holds true for digital capture, although there is no grain to speak of. Noise, the digital version of grain, interferes with accurate, or even close to accurate, color reproduction at higher ISOs.

Although this has been a much-needed focus on the manufacturers' side of things for the past few years—resulting in some phenomenal advancements—if you turn the ISO up, you are introducing the potential for a lack of color saturation and a shift in color. For example, if you zoom in 100 percent on a digital image shot at 6400 ISO, you'll notice how some pixels do not fit with the consistency of color around them. Some may be red, some may be green, but one thing is certain: they are of values that do not belong. By moving to higher ISOs, exposures render more and more inconsistent noise, especially in dark areas and of areas of largely solid coloration (**FIGURE 9.5**). Fortunately, advancements in camera technology have also paralleled advancements in software, and resurrecting color and lowering visible noise levels is a real possibility these days. However, in my opinion, it is best to start out with as much potential for color as possible rather than to try to resurrect it later.

That being said, don't let trying to always capture images with the lowest ISO force you to miss the shot. Adjusting the ISO will become second nature in time.

Good Glass Equals Good Color

I might catch some flak for this, but it is reasonable to say that shooting images with high-quality glass results in higher quality color rendering. Traditionally, the lens is purposed with focusing light and avoiding, as much as possible, any adulteration of said light (and subsequently, color) before it reaches the recording medium, be it film or digital sensor. So, it makes sense that the more pristine and clear the glass is, the less likely it is to affect the color or the clarity of an image (**FIGURE 9.6**). That is one of several reasons why more expensive lenses dig deeper into your wallet.

Nonetheless, I'm not encouraging everyone to take out loans to get into some "L" quality glass. Lenses can be mighty expensive. What else can be done to maximize color in optics without breaking the bank? How about keeping the glass clean? Always carry a lens cloth around with you. This sounds like your mother telling you to brush your teeth twice a day or wash your hands before eating, but Mom's words made sense, and you never, ever know when you might need a lens cloth. You're a photographer, and I don't know a single one—even those who have trashed cameras such as myself—who doesn't at least *try* to take care of his equipment, especially the glass in lenses.

In the same vein, avoid touching the actual exterior lens elements. Again, this seems like a no-brainer, but I can't tell you how many times I have looked at students' lenses and ever so politely *forced* them to wipe their fingerprints off of the glass. Dust and heavy smudges can potentially augment color ever so slightly, and although we may never know the difference, there's a discipline about how to treat lenses just the same. It's the same principle that keeps you from losing your lens caps. (No, I don't always keep them on, but I know where they are if I need to at the end of the day.)

On the topic of lenses and color, if good glass equals good color, it also makes sense that higher quality filters help maintain that higher quality color as well. I'm not the world's foremost expert on filters but I do know that some filters are manufactured with a higher standard of quality than others. Glass filters are created in several different quality grades, as are resin filters. Plastic filters are useful for the protection of the glass on which they are mounted, but that doesn't necessarily translate to maintaining image quality. Do your research on filters if you are interested in using them, and look for those that maintain the existing clarity of your lens. Although filters can be pricey, they are less expensive than purchasing a new lens.

FIGURE 9.6 The Canon 24–105mm f/4 L is neither cheap nor comparatively expensive, but I consider it one of the brand's sharpest and cleanest lenses—which translates to great color! (opposite page)

ISO 200, 1/500 sec., f/4, 24mm lens

BEST PRACTICES AFTER THE SHUTTER CLICKS

When you have an idea about the type or style of color you want with film, it gives you a place to start in deciding which brand and make of film will get you close. This encourages you to become familiar with the film and all related photographic issues that will manipulate that color while shooting and developing. Sometimes, even pushing chrome film one stop during processing can affect its color, and some rolls of film succumb to discoloring reciprocity during long exposures.

In a purely analog setting, though, much of what can be done for color happens during that film selection process and film's chemical reaction to exposure when shooting (notice I said much, but not all). For all-digital workflows, however, what happens to image files after the shutter is pushed can be crucial in both conveying the intended emotion and maintaining the file integrity and digital color information. This is where many digital photographers begin to differ in both style and process, so I won't treat this as a post-processing how-to. I do want to share a few general things that I do to both see the color with which I'm working and get it ready for export, though.

Calibrate that Monitor

Maybe one of the most intimidating terms in digital photography (and for good reason), calibration is all about being able to see consistent and hopefully pretty accurate color on your monitor. Not all computer monitors or digital displays are created equal. Some folks even use televisions as their main computer display, which can present color quite a bit differently from computer monitors. Working up images on one monitor may not mean seeing the exact same color, contrast, or lightness on another.

Monitor calibration at the very least creates a standard approach to color, and it can be used to reliably view more correct color on that device. This does not take into consideration whether another user's monitor is calibrated appropriately, but at least the one on which files are being processed is. I calibrate my monitors so I feel confident about the color I'm seeing and preparing for clients who I know (or assume) are using calibrated devices as well.

Calibration can be as "simple" and visually excruciating as manually adjusting your monitor's contrast and brightness levels (this is also the free option), or as complex but user friendly as purchasing and using a calibrating device and following the on-screen instructions, relying on the device itself to do the actual "looking" at the monitor. Calibration devices, whether they are colorimeters or spectrophotometers, run the gamut of pricing as well as functional capabilities, but they generally beat the price of a several-thousand-dollar Eizo monitor. Consumer-based and professional devices and software applications make what can be a headache for many of us bearable. Again, it is all for the benefit of the image. Two of the most popular and dependable monitor calibration devices include the Datacolor Spyder4Elite (which I'm currently using) and the X-Rite i1 Display Pro (and its less expensive sister, the ColorMunki). Both devices plus software are around $250, and more and less expensive alternatives are out there.

One practical benefit of monitor calibration occurs when it's paired with printing. Specifically, when it can be used in conjunction with a printing profile received from a professional printer or press. For example, all of the images in this book were converted to CMYK color space using Peachpit's own CMYK printer profile. By using a calibrated monitor that reports to me accurate and consistent color, I was able to visually evaluate what happened to my images upon conversion *and* check accuracy between my monitor and the printed page during color proofing. If the coloration was outside satisfactory limits, I was able to make adjustments on my monitor at that point, knowing that the adjustments were specifically for Peachpit's printers.

If you use a local printer, I suggest contacting it to see if you can obtain its profile for soft proofing. Likewise, if you are interested in printing your own images, it behooves you to learn as much as you can about calibration for both your monitor and your printer (here's a great place to get started: www.cambridgeincolour.com). For those of you who upload your images to a high-quantity online-based printer, such as MPIX, you will be able to find specifics for preparing color on its websites. If you want more specific information, you can always contact the company directly.

Start off subtly in post

No matter the post-processing software, working with color has never been easier, never more nuanced, and never more detrimental. Don't get me wrong, I rather enjoy color work, even though my own workflow is rather simple. However, new photographers learning how to use software such as Adobe Lightroom or Photoshop can have a heavy hand when it comes to color saturation and vibrance. It is inappropriate to pass judgment on how far a photographer pushes his or her colors, particularly since this choice is such a strong facet of many shooters' personal *and* professional styles, but I do encourage doing so with a working knowledge of the common controls.

Different applications identify their controls with similar monikers, but most are built around adjusting contrast, hue, saturation, and lightness (the latter three comprising the HSL controls in Adobe products). Contrast adjusts the difference between dark and bright values in an image, either reducing the difference (decreasing contrast) or increasing it (increasing contrast). By increasing or decreasing the contrast, color is affected as well.

Increasing contrast usually saturates color due to the compressing of more extreme light values, and decreasing has the opposite effect. Clarity, on the other hand, is a relatively new control that adjusts contrast around midtones in an image, and increasing it usually results in a drop of color saturation and at the same time introduces a signature edginess (**FIGURE 9.7**). I'm not shy in saying I have a love-hate relationship with Clarity. As with all tools, it is easy to take it too far. Sometimes, it lacks the nuance necessary for adjusting certain images—pretty soon you find yourself wondering what happened to both your color and the fine details in an image.

Whereas Contrast manipulates color based on differences in light values, Hue, Saturation, and Lightness manipulate the color itself. When adjusting hue, the selected color will actually change along a continuum that involves all colors possible. Software makes it rather easy to change blue to purple, or red for that matter, by augmenting a color's hue. Saturation adjusts the boldness of a specific (or all) colors, depending on which set of controls is being used. Lightness changes the brightness value of a color. Increasing the brightness of red can easily result in pink, while decreasing it will result in a scarlet.

Depending on your style or visualization of the final product, I encourage making adjustments to color with a subtle touch (**FIGURE 9.8**). In doing so, we become more familiar with how much is actually being changed. Personally,

FIGURE 9.7 I use contrast to boost what the Raw image visually lacks in color and general edge. For this image, I also increased the Clarity function to increase the contrast of the midtones, forcing the cotton modules themselves to stand out against a darker background.

ISO 200, 1/100 sec., f/5.6, 17mm lens

I start with contrast, and with many images, I will move the slider more than what I will actually use in order to see exactly what is happening as I bring it back.

Given the right light conditions, many photographs only need slight tweaks to contrast. Raw files especially scream for contrast adjustments since they typically exit the camera flat (but full of information) when compared with already-processed JPEGs. I often do not even touch the global saturation and HSL controls, but I do find them useful when making color conversions to different color spaces. However, I'm especially careful when making these adjustments and use them mostly for color correction as opposed to effect.

To each their own, though, and I encourage you to explore not only the functions I've identified but all controls for color work in post.

Compress Only at the End

Briefly put, work with as much information as possible at all times. (We've touched on this before, in discussions of Raw files.) Remember, it is all about control. If you are shooting in Raw, make as many adjustments, including those that affect color, in the Raw file reader as you can before exporting the file as a compressed JPEG.

If you must continue work in Photoshop or other image processing software, I suggest opening the file from the Raw reader straight into the program *or* saving it first as a lossless compression format, such as TIFF or as a Photoshop Document (PSD). The reason we typically want to use

FIGURE 9.8 Working in good light does quite a bit of the color work for the photographer. However, due to the lack of processing a Raw file has inherently, a slight contrast boost and an ever–so–light touch of saturation for the reds makes this trio of Indian blanket flowers pop off the recessive bluebonnets.

ISO 200, 1/800 sec., f/2.8, 145mm lens

FIGURE 9.9 Post–processing alone cannot account for image content that is worth viewing. A sense of joy is conveyed here not only by the actions of the two women and small child but also by the colors surrounding them.

ISO 100, 1/500 sec., f/2.8, 17mm lens

lossless compression file formats is that when we save our adjustments along the way, the information in the file is not compressed in a way that throws vital information out.

JPEGs, on the other hand, suffer from lossy compression, which results discarding structural information each time a file is saved. This type of *destructive* editing can result in loss of color detail, and within only a few saves that loss will become apparent to the trained eye. A particularly work-heavy JPEG might necessitate many "saves," doing great damage to the visual attractiveness and integrity of the file.

Some photographers, such as sports shooters, must work in JPEG for efficiency purposes. If an image needs a quick edit, then usually one save over or export won't hurt. But, if you anticipate more, it is best to save the original JPEG as a TIFF or PSD for working the file up, then resaving as a JPEG for export.

I have no doubt you will find your own best practices for your color workflow. There are many great resources for post-processing out there, and each contains information about the controls that allow you to correct, control, and manipulate color. In the end, though, you will decide on how to work with color for *your* images. I do believe that the suggestions above, though, prepare you to get the maximum amount of flexibility and information out of your digital files when it comes to color.

Of course, the post-processing and digital file structuring do not supersede the value of being able to see, compose, and expose color with great content in your images. Long before the advent of photography, let alone digital technologies, artists and communicators alike knew that color was powerful, and being able to use it to direct the eye, create depth, and convey emotion contributes to the power that images, including photographs, have in the world (**FIGURES 9.9** and **9.10**). Photographers recognize this power, and only on this foundation will you really see your images take off!

FIGURE 9.10 A beautiful sunset and its reflective color on the Llano River near Junction, Texas. Experiencing color occurs behind the camera just as much as it occurs in front of a print or computer screen.

ISO 100, 1/5 sec., f/22, 18mm lens

A Nod to Black and White

Given that this is a book about color, I haven't said much yet about black-and-white photography. My focus on color in the previous chapters is not because I disdain black-and-white photography or consider it valueless. I just wanted to concentrate on the power of color and its attractive draw to the eye. I've been taking a shooter's look at how we use color to compose, guide a viewer through a shot, and provide subtle or strong meaning. Black-and-white photography does those things, too, of course, in its own way and has been doing so for much longer. In some circles, it is considered the only way to shoot, whereas in others, it intimidates or puts off photographers. You could say that its very simplicity can seem overly complex to some.

ISO 1600, 1/60 sec., f/2, 50mm lens

Honestly, I don't shoot all that often with the intention of converting to black and white. My clients don't call for it, and my personal shooting usually involves color as much as my assignment work does. However, at times thinking—and seeing—in black and white, and subsequently converting to it using post-processing software, can not only be appropriate but more powerful than keeping an image in color. This chapter investigates a few of these situations.

COLOR OVERLOAD

As much of a proponent of color as I am, it is only truthful to state that it can be extremely overbearing and distracting at times (**FIGURE 10.1**). A quick glance at the images in this book reveals that for color to really stand out and make an impact on the story being told or on the viewer, it is usually a fairly simple abstract mixture of two or three distinct colors. Complementary colors often vibrate most intensely when they are the main or only colors present in the frame. In some cases, an image composed of analogous colors is all you need to strike a chord with a viewer. I'm reminded of legendary photographer Elliot Erwitt's body of color work (highly recommended for your own study) when considering how powerful the simple use of one dominant and one recessive color can be.

However, the world is often not so neatly colored. As photographers, we train ourselves to see patterns, leading lines, great light, and yes, color. There are times, though, when all of those things come together except for color. As discussed at the end of Chapter 4, a wide variety of color in a frame without some sense of aesthetic organization can result in sensory overload.

For an organ that can process visual information very quickly, the eye can just as easily be distracted, confused, or, at the very least, stressed without good use of color combined with other aesthetic principles photographers and other artists employ. When you're shooting in an environment with a wide range of colors that lack any structure and could be quite visually confusing, consider looking at the scene in black and white (**FIGURE 10.2**). As a new father, for instance, I'm surrounded by bright colors of all kinds—children's toys, books, and blankets. A great way to mitigate the "noise" of those colors is to go black and white in post (**FIGURES 10.3** and **10.4**).

FIGURE 10.1 A fair midway can be excitingly colorful— colorful enough to cause some visual anxiety when composing certain images.

FIGURE 10.2 With color absent from the image, the eye has one less thing to assess before the mind takes over.

ISO 100, 1/4000 sec., f/2.8, 50mm lens

FIGURE 10.3 A baby's life is full of colors of all kinds. Sometimes, however, they can inundate the senses when photographing little ones.

FIGURE 10.4 A black–and–white conversion takes the distraction of the large block of red behind the baby's head away and removes the clash between the brown clothing and the colorful environment, ultimately helping us focus on the infant.

ISO 400, 1/50 sec., f/2, 50mm lens

Seeing and previsualizing in black and white takes practice, but scouting each location as if you're seeing in black and white helps you quickly acknowledge the potential the shot has for a black-and-white conversion. It also forces you to look even more at the colors in the shot, and if they present a problem, perhaps think about trying black-and-white conversion in post.

Heavy amounts of vibration equate to colorful dysfunction in a shot, and converting all values to a shade of gray removes the undue influence color can have on a shot. Content is very important in your images, and if you aren't able to compose effectively in a given situation by taking advantage of the colors at hand creatively, sometimes the best option is to make the black-and-white conversion (**FIGURES 10.5** and **10.6**).

SETTING UP FOR BLACK AND WHITE FROM A COLOR PERSPECTIVE

Shooting in black and white does not mean employing an extra set of rules when it comes to using your camera. In fact, leave the camera alone. Continue to shoot in color. Do not change your camera's color style to black and white. Remember, this is all about control—you want it, and you can take it by giving yourself options!

Do not let the camera's onboard computer make any post-processing decisions for you that you can make after uploading the images to your computer. If you are shooting in Raw—and you should be—you will always be shooting in color. The Raw digital file is capturing the totality of information your sensor is capable of, and even though the image appears black and white on the back of your camera's LCD, the color information is still there. Keeping your files in color also allows you a bit more flexibility. Perhaps the shot was a great one in color, but you also want to try out black and white. Always shooting in color is the type of insurance that covers both situations.

Make all black-and-white conversions using a post-processing application. I am a fan of Adobe Photoshop Lightroom. Aside from being a great workflow application, it also handles converting Raw color files to black and white very well. The controls are very intuitive for anyone who has done any work in a darkroom processing film, and the software continually improves with each iteration. In addition, like similar applications, Lightroom allows for nuanced control over existing colors in a shot. Essentially, functions in Lightroom let you digitally burn or dodge a wide range of specific colors in a shot. So, if you want your reds (when red is in the original image) darker, you simply dial it in. Oh, and that Clarity slider I was complaining about in Chapter 9? It becomes an exciting tool in black-and-white conversions using Lightroom.

Lastly, Lightroom also incorporates third-party black-and-white plug-ins with ease. A black-and-white plug-in like Nik Silver Efex Pro brings even more control to your black-and-white conversions, and Lightroom makes using it a one-click process.

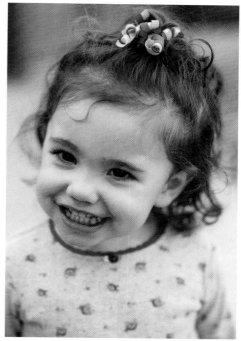

FIGURE 10.5 Unbalanced color temperatures caused by a golden light reflecting from a fence made this quick portrait of my daughter feel visually awkward (top right).

FIGURE 10.6 The two different light colors are quickly balanced with a black–and–white conversion. Now, the concentration is on great light and a cute face (lower right).

ISO 100, 1/200 sec., f/2, 50mm lens

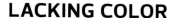

LACKING COLOR

Have you ever been in a situation when you have some nice light—let's say for a portrait—and you have the right face, but beyond the person's own pigmentation, you really have no color to speak of (**FIGURES 10.7** and **10.8**)? Perhaps it is actually the environment that lacks a popping color you stylistically crave or the light itself is not that colorful, such as that produced by heavy clouds. In some cases when the environment, for whatever reason, lacks strong color, converting to black and white is a better option (**FIGURES 10.9** and **10.10**).

Color is not the only thing light creates. A nice play of light means great shadows as well. By converting to black and white, we are able to drive attention to light and shadow alone. This might result in a mood change, an emotional softening, or a dramatic departure from the original. In either case, a black-and-white conversion in this case might be exactly what the image needs to stand out. A lack of color overall might be just as distracting as sensory overload of many in-your-face colors (**FIGURES 10.11** and **10.12**). Converting to black and white does away with this small distraction and allows you and the viewer to enjoy the light and content. This is simply a different way of using the visual language we become accustomed to as photographers.

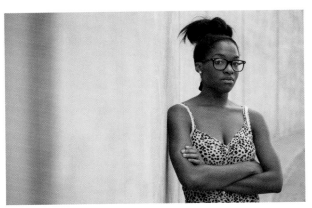

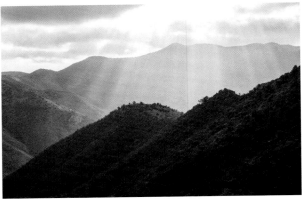

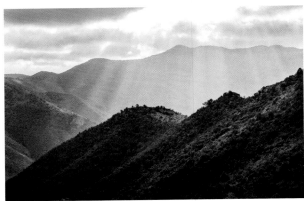

FIGURE 10.7 A nice setup for a portrait—a curved wall, soft, directionally diffused light, but no real excitement in the overall color of the frame.

FIGURE 10.8 Instead of pumping color into it in post, using a black–and–white conversion accents the cleanness of the environment and allows Whitney to dominate the scene.

ISO 400, 1/600 sec., f/1.4, 35mm lens

FIGURE 10.9 The sun is high in the sky, and the color on the mountainsides is lacking.

FIGURE 10.10 A black–and–white version of the image does away with any hint of color, pronounces the contrast between what is lit and what isn't, and allows the "God rays" to stand out more.

ISO 100, 1/160 sec., f/9, 50mm lens

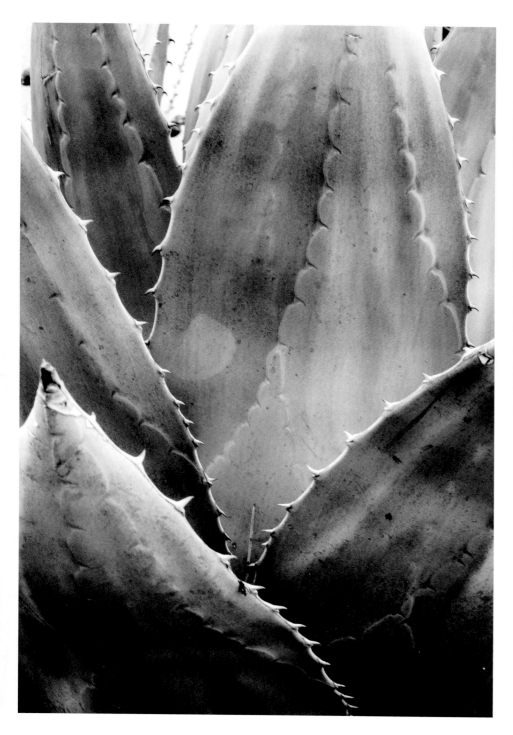

FIGURE 10.11 I loved the pattern in this yucca plant, but the diffused light left the color without any punch.

FIGURE 10.12 Highlights and subtle shadows become more pronounced in black and white, even if the light is extremely soft.

ISO 1600, 1/15 sec., f/16, 35mm lens

FIGURE 10.13 High-contrast lighting, although fairly nice in this case, creates hard, blocky shadows and borderline overexposed highlights.

FIGURE 10.14 This same light is the foundation for quite a bit of black-and-white work in landscape or portrait photography.

ISO 100, 1/40 sec., f/14, 26mm lens

HIGH CONTRAST

I have a distinct memory from a long time ago, when I was just starting out in photography, when a friend told me she was going out to shoot stock assignment images in the middle of the afternoon. Being the staunch devotee of the golden hour that I was in those days, I asked her why in the world she would want to do that. Her reply was that the high-contrast light at that time of the day was great for black and white. It struck me that she was correct, especially if high contrast black and white was what she was after (**FIGURES 10.13** and **10.14**).

In a lighting situation such as a bare sky afternoon, the extreme difference between lit areas and those covered in shadow may easily exceed our camera's dynamic range. What does this mean? It means that if we expose for something that is lit, we'll severely underexpose detail in the shadows. Vice versa, if we expose for the shadow, the lit areas will potentially blow out. In any case, color suffers in these types of lighting conditions. Natural light is stark at these times, and colors simply do not pop the way they do earlier or later in the day. Likewise, color in the shadows may not even show up if you expose for subject matter in the lit area, as well as the opposite.

Take advantage of a high-contrast lighting situation by shooting with the black-and-white option in mind (**FIGURES 10.15** and **10.16**). Continue to shoot in color, but see the environment in black and white, particularly in terms of how you might process your own black-and-white work. You might not be able to make that color really pop, no matter your efforts in post, but a clean conversion to black and white might make up for no color (**FIGURES 10.17** and **10.18**).

FIGURE 10.15 Close to noon, the shadows say quite a bit about the time of day and, in the case of these oil field workers, the ruggedness of their work (left).

FIGURE 10.16 The interpretive value of the high-contrast light potentially increases in black and white, where the shadows seem harsher, even though software allows us to make them more forgiving (below).

ISO 100, 1/1000 sec., f/4, 24mm lens

FIGURE 10.17 A high-contrast setting made for a sweet mother-daughter silhouette (left).

FIGURE 10.18 The slight tinges of blue in the sky and the window frame are removed in black and white, mitigating their potential distraction when focusing on the moment between the two people (below).

ISO 1250, 1/30 sec., f/5.6, 18mm lens

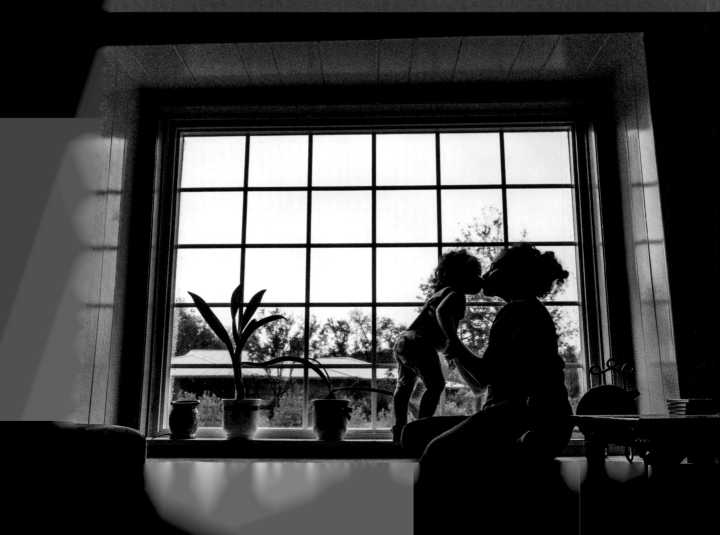

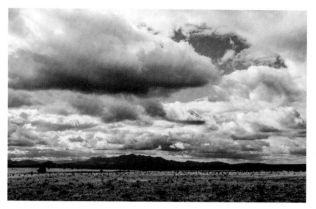

Again, the shadows created by stark lighting can be useful, especially when we do not have to perceive a slight coloration to them or even view unrealistic color pumped back into them as a result of trying to deal with the lack of color at that time of day (**FIGURES 10.19** and **10.20**).

Of course, this applies to studio or artificially lit situations as well. I love high-contrast black-and-white portraits that intentionally use intense, hard light sources. I especially like shooting these portraits on black backgrounds (**FIGURES 10.21** and **10.22**). We also often see this type of light used in conjunction with a technique called short lighting (**FIGURES 10.23** and **10.24**), in which the light is placed more behind the subject than in front, resulting in shadows falling toward the camera. There's a seriousness or formality here that color in the same situation cannot convey as well.

SIMPLIFY

Black and white does simplify and declutter an image. It simplifies the frame from not only a technical or physical perspective but also from a message or story perspective. Color can be our best friend, but if it gets in the way of telling story or conveying some sort of meaning in our art, then it becomes a problem—a problem that makes the frame more complex than what you intended (**FIGURES 10.25** and **10.26**).

FIGURE 10.19 An early-afternoon look at a barren New Mexico landscape (above left).

FIGURE 10.20 The shadows of the clouds, made more pronounced in a black-and-white conversion, provide a substantial weight to the image, and the short shadows of the scrub dotting the land quickly drive home the notion that this is indeed a desert (above right).

ISO 100, 1/125 sec., f/16, 51mm lens

FIGURE 10.21 A self-portrait from a few years back using a short-lit soft box. *Duck Dynasty*, anyone?

FIGURE 10.22 Converting high-contrast black-and-white images sometimes brings out great detail that gets marred by color, such as beard hairs that catch hints of light and skin pores that create small shadows. This detail, if accentuated during the conversion, adds a bit more grittiness to the portrait.

ISO 100, 1/200 sec., f/8, 68mm lens

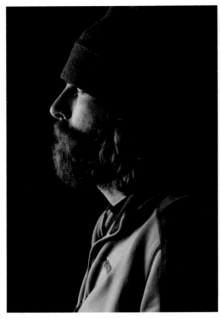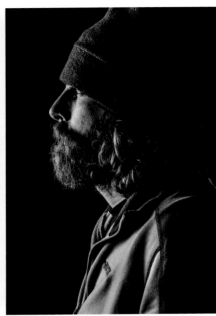

FIGURE 10.23 A natural, short-lit portrait forces nice shadows *toward* the camera, creating a dramatic, cinematic effect in conjunction with the lower angle.

FIGURE 10.24 Focusing attention on the quality of light and shadow, a black-and-white conversion also accents the model's figure more and gives the portrait a more statuesque personality.

ISO 400, 1/210 sec., f/2.4, 60mm lens

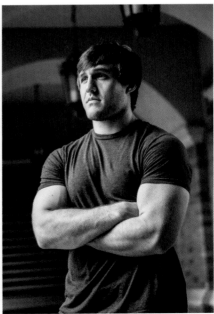

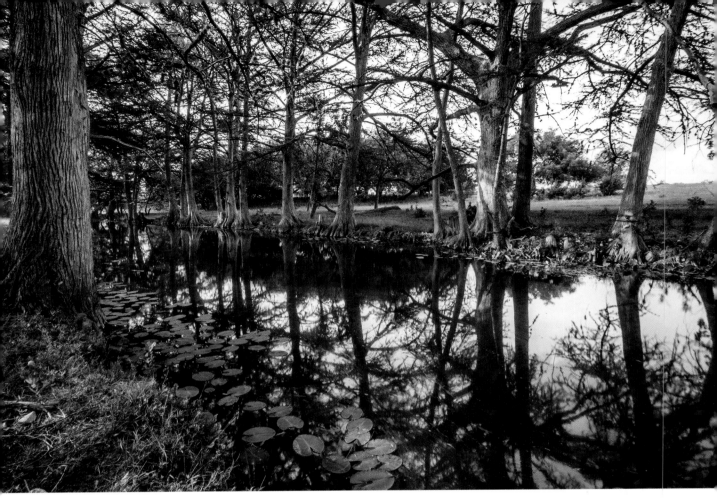

FIGURE 10.25 Shot a little later in the morning than the golden hour, this shot is anything but simple (left).

FIGURE 10.26 Even though the complexity of the trees still exists, color is no longer a factor to dwell on. The black–and–white conversion also did away with the murkiness of the water, accenting the reflections more than the moss (above).

ISO 100, 1/4 sec., f/22, 17mm lens

We see thousands of images on a daily basis. How do we make ours stand out? In some cases, it is by making them look different. In many other cases, it is through relying on simplicity for maximum impact. Take away the complex backgrounds, the noisy compositions, and in some cases, the color altogether (**FIGURES 10.27** and **10.28**). Use strong light and great content, and you will come away with a simpler yet evocative image (**FIGURES 10.29** and **10.30**).

This entire book has been about directly engaging your viewers by studying, finding, and implementing great color in your photographs. Even if we simply chance upon color in our images, our knowledge about it allows us to use it in effective ways. However, when it can't be exploited to make our images stronger, a nice, less complex alternative is to visualize and shoot for black and white.

For some photographers, simplification is a style, while for others it is a philosophy. It is hard to determine how and when to introduce simplification into your own work, but converting to black and white for a portion of your photography might be a good first step.

RESOURCES FOR DIGITAL BLACK-AND-WHITE PHOTOGRAPHY

This chapter alone cannot cover the full scope of digital black-and-white photography, so it is worth mentioning a couple of my favorite resources for such work and conversion techniques. For the black-and-white enthusiast, I recommend taking a look at John Batdorff's *Black and White: From Snapshots to Great Shots*. John is a whiz at black-and-white work, and his book is also an excellent resource for learning the Nik Silver Efex Pro black-and-white software plug-in mentioned earlier. Another title worth adding to your collection is Vincent Versace's *From Oz to Kansas: Almost Every Black and White Conversion Technique Known*

to Man. Vincent is an acclaimed fine-art photographer, and his black-and-white work runs the gamut of classically inspired to innovative.

Both books not only instruct readers on how best to approach making great black-and-white conversions in post, they also stress the importance of being able to see in black and white, the mechanics behind making black-and-white images before post-processing, and the environments and shooting situations that are especially conducive for black-and-white photography.

FIGURE 10.27 A simple, clean portrait, except for the newborn skin coloration (above).

FIGURE 10.28 Simplification pushed to the maximum here, where viewing eyes rest only on the infant (left).

ISO 640, 1/40 sec., f/2.8, 130mm lens

FIGURE 10.29 A long hike paid off with some great light at the top of Mesa de los Fresnos in the Carmen mountain range in northern Mexico.

FIGURE 10.30 Almost a stereotype of black–and–white landscape photography by now, the lone tree atop the mesa became even lonelier with a black–and–white conversion.

ISO 100, 1/100 sec., f/10, 17mm lens

WHEN YOU FEEL LIKE IT

We are photographers in a day and age when we have the luxury of shooting in color format and converting to black and white later if we desire. We may have philosophical and technical—even strategic—reasons for converting our digital files to black and white, but sometimes, we simply just feel like it (**FIGURES 10.31** and **10.32**). There is nothing wrong with being curious about a black-and-white conversion or just being in a black-and-white mood.

FIGURE 10.31 A lovely sunset sits above a harvested cornfield in West Texas (below).

FIGURE 10.32 Curious to see what the image would look like in black and white, I was pleased with how the waving corn stalks bring on the sense of coming winter, as do the monochromatic clouds (right).

ISO 100, 1/50 sec., f/5, 17mm lens

Embrace this mood. Be just as open to seeing and discovering black-and-white images as you are with your color work (**FIGURES 10.33** and **10.34**). If anything, it will hone your skills at spotting and using great color in your photography (**FIGURES 10.35** and **10.36**). I love color. But I'm not averse to considering the possibilities of black and white. In fact, I do not know a single photographer—especially professional ones—that closes his or her mind off to black and white. Some of the most compelling black-and-white work I have seen has come from shooters who shoot predominantly color work for magazines. I suppose this could be because they find themselves wanting to work in a mode that they are not as married to—it gives them a chance to break their work up a bit creatively and stylistically.

Black and white often forces us into a zone of thinking that we would not explore otherwise (**FIGURES 10.37** and **10.38**). It might even change how we use our equipment or the equipment we choose to use. It sounds silly, but when I use my mirrorless cameras, such as the Sony NEX-6 or the Fujifilm X-E1, I tend to think in black and white more. There may be no rhyme or reason behind that, but those cameras inspire me in a way that encourages me to think black and white first. Perhaps it's the Fuji's retro styling and functionality, or maybe it's the Sony's range finder–like quietness to the shutter,

FIGURE 10.33 A cotton stripper and buggy move slowly along the horizon as evening lights their activity.

harking back to the classic images from early notable shooters like Henri Cartier-Bresson and W. Eugene Smith.

I'm not considered a street photographer, but when I am in that mode, I'm also thinking black and white (**FIGURES 10.39** and **10.40**). I may be influenced by a lot of black-and-white street photography work out there, but ultimately, I often just feel like going black and white in an urban setting (**FIGURES 10.41** and **10.42**).

FIGURE 10.34 Cotton harvesting has long been a tradition on Texas's southern plains and rolling eastern plains, and a black–and–white conversion of this image enhances a sense of history.

ISO 100, 1/105 sec., f/4.5, 105mm lens

FIGURE 10.35 Shooting a roping practice at the end of the day with the riders moving from west to east while chasing the calf, I knew I was going to be dealing with a blown sky and muddy shadows (right).

FIGURE 10.36 Black and white was my only intention during this shoot, previsualizing it before I even snapped the frames. The sky is less distracting and even complements the darker tones of the activity below when converted to black and white (below).

ISO 1600, 1/45 sec., f/1.4, 35mm lens

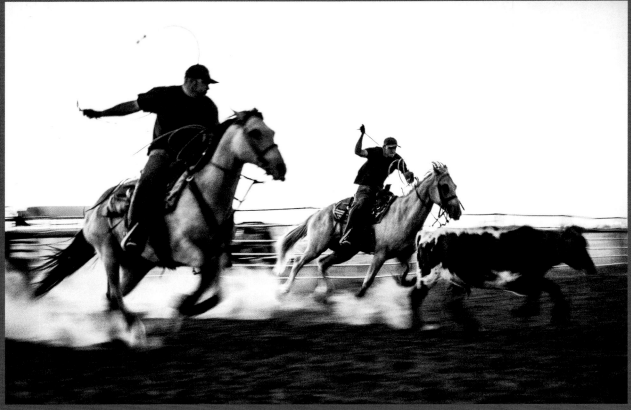

FIGURE 10.37 I don't normally find myself walking the streets at night, but an evening in Santa Fe, New Mexico, found me wandering in search of potential black-and-white work, such as this moonrise over an adobe building.

FIGURE 10.38 In black and white, the moon seems more overbearing and the shadow of the streetlight is pronounced as it frames a portion of the building.

ISO 3200, 1/20 sec., f/2, 50mm lens

BLACK AND WHITE VERSUS COLOR

Black and white versus color isn't some contest to see which one is better. It is all about what we are creating, what we want it to say, and how best to tell a story. Photographers versed in both color and black and white bring more to the table, both creatively and strategically. When many photographers would choose to reminisce about shooting Tri-X black-and-white film, their days of working in the darkroom and filling their nostrils full of the unforgettable smell of processing chemicals, I'll always fondly remember the first time I processed my first roll of Fujichrome Velvia 100, when my relationship with color became a bit more serious. Both have their advantages.

FIGURE 10.39 My efforts in street photography are always influenced by how I see a black–and–white conversion affecting the image (top right).

FIGURE 10.40 Black and white does away with the inconsistent mixture of color in the frame and accents the type of light hitting the gentleman with the cup, as well as the feeling of contemplativeness he has (lower right).

ISO 200, 1/1800 sec., f/1.4, 35mm lens

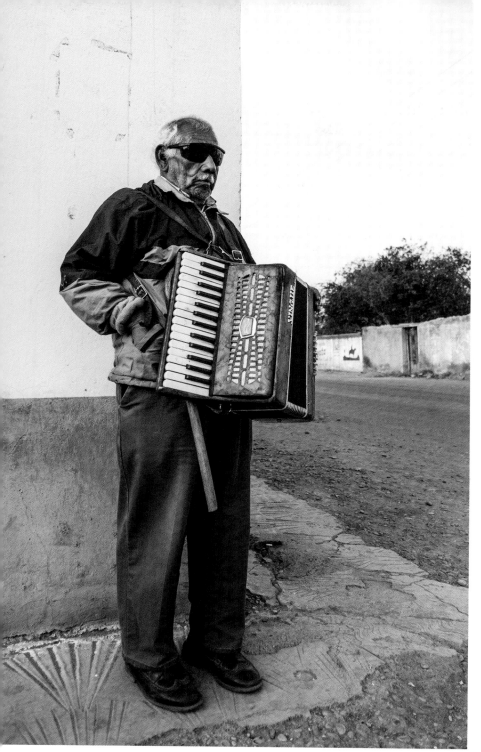

FIGURE 10.41 An accordion player stands on the corner of a small Mexican town in eastern Coahuila. Great portrait light, great subject, even good color. Why change anything (above)?

FIGURE 10.42 A classic black–and–white conversion adds a sense of age to the shot that correlates with that of the musician—a simply processed digital image for a no–nonsense life that man lives (left).

ISO 100, 1/500 sec., f/4.5, 24mm lens

Index

photography. *See also* black-and-white
 photography; color photography
 black-and-white *vs.* color, 6–8,
 244–245
 concepts of light for, 30
 importance of color theory for, 48
photoreceptors, 23–24
Photoshop, 187, 216, 218, 226
Picture Styles, Canon, 208–211
plastic filters, 212
Plaza Mayor, 125
poison ivy, 88
Popular Mechanics, vii, ix
portraits
 adding drama to, 150
 black-and-white *vs.* color, 227, 228,
 234, 237
 black background for, 111
 and color-correction gels, 188
 cultural clues in, 117
 golden-hour light for, 150
 lighting for, 164, 172, 173
 red background for, 76
 separating subject from background,
 164
 shadows in, 111
 visual contrast in, 111
 white-balancing, 184
post-processing software, xii–xiii, 187,
 197, 216, 220, 221
primary colors, 49
printer calibration, 215
printer profiles, 215
PSDs, 218, 220
purity, 107
purple, 101–105

R

rain, 161
rainbow, 132, 133
ranch scene, 101–103
Raw file format, 187, 202–205, 206,
 208, 217, 226
recessive color, 57–63
red, 74–79, 130

reflections, 30, 60, 157, 159, 235
reflectors, 187
religions, 133
religious figures, 104, 105
religious symbols, 104, 133
residential areas, 121–125
restaurants, 94–95, 117
retina, 23
RGB color space, 206–207
Riley, Bridget, 54
rock 'n' roll, 135, 142
rods, 23–24
roping practice, 242
royalty, 104
rule of thirds, 39

S

sadness, 82
Santa Fe
 architecture, 125
 doorway, 152
 moonrise, 243
saturation, 197, 204, 209, 211, 216
saxophone player, 104
schools, 133, 135
science, color, 18–21, 23–24, 59
Scotland
 farm field, 52
 garden, 34
 landscapes, 176, 177, 208–209
scouting locations, 173
seasons, 165–169
secondary colors, 49
seeing red, 76
sensory overload, 64–65
shade, 57, 63, 153
Shade white balance, 177
shadows
 adding depth/texture with, 30, 64
 in black-and-white photos, 227, 229
 in flower shots, 153
 in mountain landscape, 80–81
 in portraits, 111
simplifying images, 233–237
singer, 23

skin tones, 186, 189
skull, 83
sky, 161–164. *See also* sunsets
 clouds in, 162–163
 color and texture in, 59
 and color temperature, 21
 contrast setting for, 217
 describing color of, 21, 23
 lightning bolts in, 143
 natural colorcast of, 164
 nighttime, 144
 underexposing, 198
Smith, W. Eugene, 241
Sony NEX-6, 240
sorghum fields, 133
Spain
 cathedral, 60
 doorway, 56
 Jesus Christ painting, 105
 Plaza Mayor, 125
 residential structures, 122, 124
 roofline, 120–121
 signature coloration of, 12–13
 tapas, 114–115
 Temple of Debod, 159
 traditional clothing, 129
 upholstery store, 65
spectrophotometers, 215
speedlights, 187, 188
sports organizations, 135
sports photography, 220
spotlights, 195
spring colors, 165
Spyder4Elite, 215
sRGB color space, 206
stacking colors, 66
stage lights, 169, 171, 173
Standard Picture Style, Canon, 208–211
storytelling, color's role in, 12–14
strawberries, 118
street photography, 241, 243, 244
strobes, 187, 188, 191, 195
studio flash systems, 195
studio photographers, 48
subcultures, 113, 133–139

WATCH READ CREATE

Unlimited online access to all Peachpit, Adobe Press, Apple Training and New Riders videos and books, as well as content from other leading publishers including: O'Reilly Media, Focal Press, Sams, Que, Total Training, John Wiley & Sons, Course Technology PTR, Class on Demand, VTC and more.

No time commitment or contract required! Sign up for one month or a year.
All for $19.99 a month

SIGN UP TODAY
peachpit.com/creativeedge